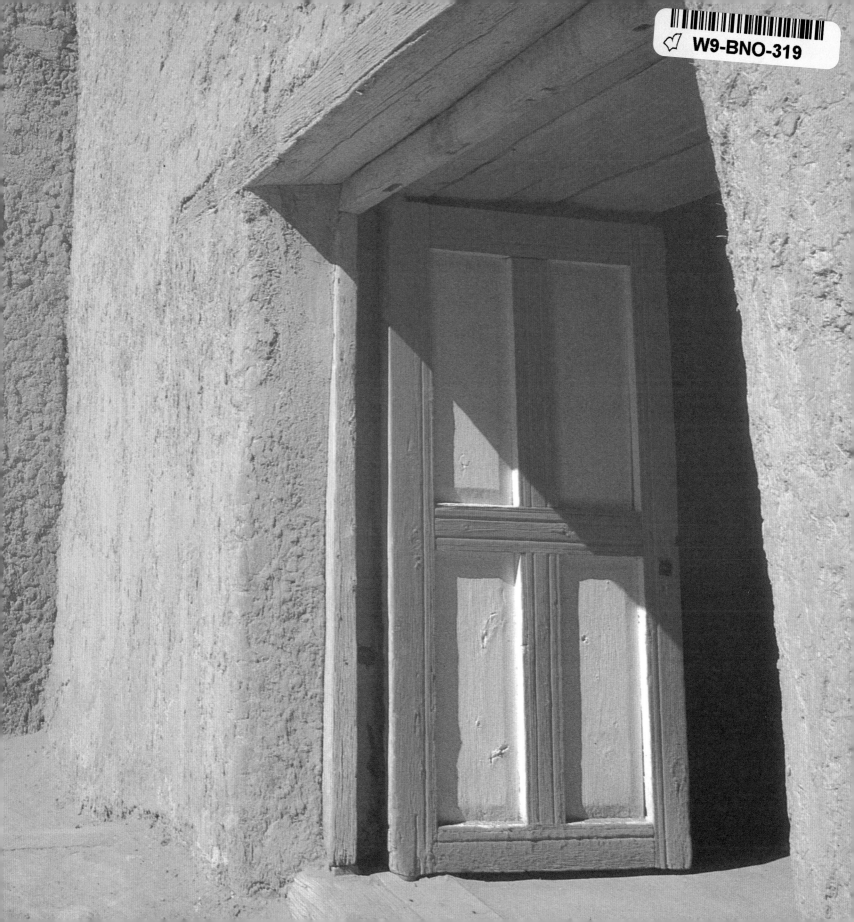

DOORS

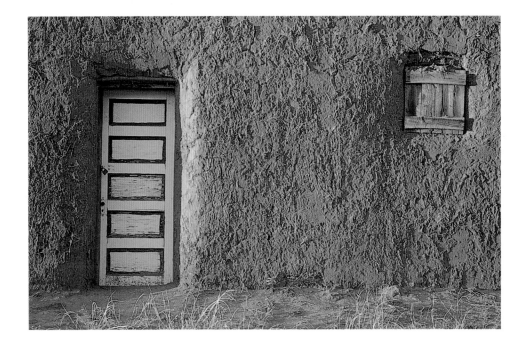

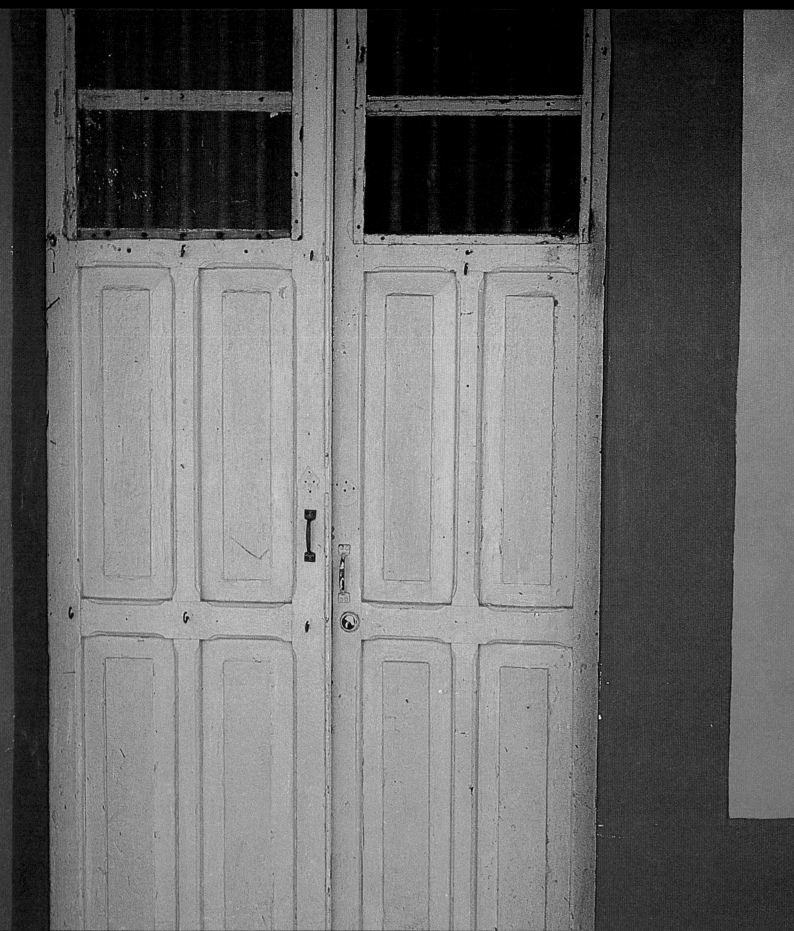

DOORS

FRIEDMAN/FAIRFAX
PUBLISHERS

A FRIEDMAN/FAIRFAX BOOK

© 1998 by Michael Friedman Publishing Group, Inc.

Library of Congress Cataloging-in-Publication Data available upon request.

ISBN 1-56799-618-3

Editor: Celeste Sollod
Art Director: Jeff Batzli
Designer: Garrett Schuh
Photography Editor: Wendy Missan
Production Director: Karen Matsu Greenberg

Color separations by Colourscan Pte Ltd.
Printed by Leefung–Asco Printers Ltd. in China

1 3 5 7 9 10 8 6 4 2

For bulk purchases and special sales, please contact:
Friedman/Fairfax Publishers
Attention: Sales Department
15 West 26th Street
New York, New York 10010
212/685-6610 FAX 212/685-1307

Visit our website:
http://www.metrobooks.com

When you follow your bliss..., doors will

open where you would not have thought

there would be doors; and where there

wouldn't be a door for anyone else.

—*Joseph Campbell*

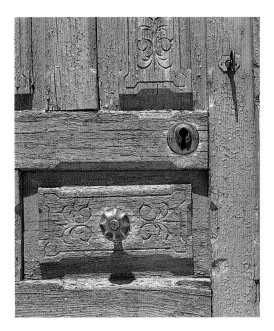

oors are among the world's oldest symbols. To the ancients, many things echoed with associations and meaning, but in our own age only a few objects still glow with poetry, opening our imaginations and hearts to wider, deeper realms of understanding. Among these resilient, resonant artifacts, doors hold a significant place, turning up, often unnoticed, throughout our daily speech and thought. When one door shuts, another opens. Opportunity knocks, and the postman always rings twice. Doors keep the outside out and the inside in. Doors stand for those permeable and powerful boundaries between ourselves and others, between innocence (or ignorance) and knowledge, and much of the imaginative, even erotic, power of doors derives from that association.

Doors divide the inside from the outside, literally defining home. Thus they are images of safety, cosiness, hospitality, and warmth. But they can also conjure mystery and secrets.

Doors play a starring role in children's imaginations: make-believe entrances and exits are important parts of childhood games. In children's literature a wardrobe door may be the entrance to a magical land like Narnia; in a fairy tale the door may be a barrier, like the locked door to Bluebeard's secret chamber, hiding forbidden truths. As children grow older, they learn to fear the massive and dreadful creaking oaken panels of horror films.

Pointing to a door, we say, "This is where I live." We are most ourselves at home, and the door is the means by which we invite others into our home or keep them out. Because our doors form the transition points between our public and private worlds, their appearance matters. The shape of a door, the direction in which it faces, how it is adorned, indeed, whether it is obvious or concealed: all of these questions have concerned humans since we first sought shelter. *Cave canem,* "Beware of the Dog," is a warning at least two thousand years old. Navajos traditionally built their hogans with the door facing east. The ancient Chinese art of feng shui considers the placement of the door very important in achieving the most harmonious arrangement of energy in a home. And how old is the debate about whether the good-luck horseshoe over a door should be placed with the open end up to keep the luck in, or down, which gives it the shape of a portal?

In countries of Mediterranean culture today, a wedding is announced to the neighborhood with a white tulle wreath on the family door, a birth with pink or blue, and a death with black. In North America, autumn is a time to adorn the door with the bounty of

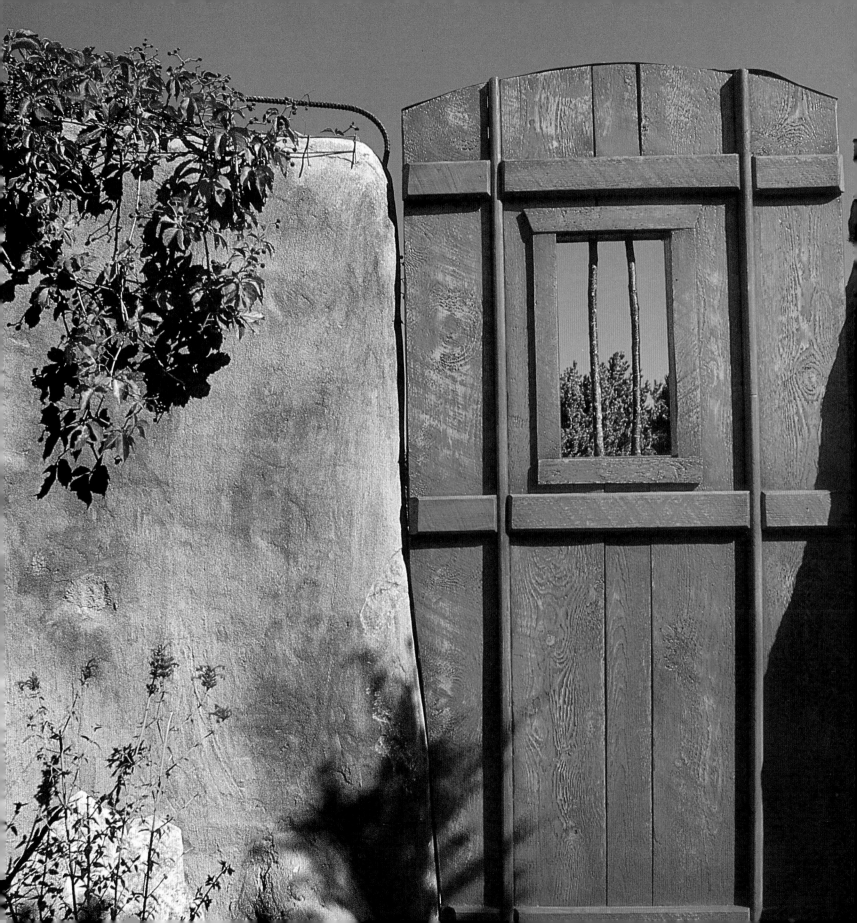

the harvest, such as ears of multicolored corn, perhaps an unconscious sacrificial tribute in gratitude for Nature's abundance. At Christmas, a wreath of evergreens with a red bow commemorates life in death, or the Christian hope of life after death. It also recalls the colors of holly, that tree that shines with living green leaves and bright red berries in the silent white of northern winters. With that wreath we relive the pagan celebration of the solstice, that timeless moment of relief when the days begin once more to lengthen. In the zodiacal language, the winter solstice—usually December 22, beginning the sign of Capricorn—is the *janua coelii*, the door of the gods, the emergence of the sun's increasing power. The summer solstice, usually June 22, beginning the sign of Cancer, is the *janua inferi*, the door of men, the onset of the sun's diminishing force.

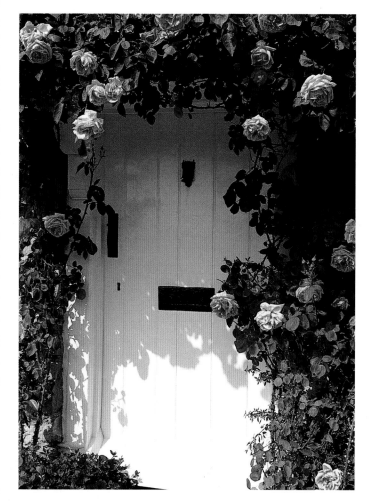

In Deuteronomy 6:4–9, and substantively repeated in 11:13–20, the Torah twice makes explicit the identification between a person and the doors of his or her home. Deuteronomy 11:18–20 enjoins:

Therefore impress these My words upon your very heart: bind them as a sign on your hand and let them serve as a symbol on your forehead...and inscribe them on the doorposts of your house and on your gates—to the end that you and your children may endure, in the land that the LORD swore to your fathers to assign to them, as long as there is a heaven over the earth.

These are the words traditionally contained in the *mezuzah* (the word itself means "doorpost"), which observant Jews have been affixing to their doors since as early as 515 B.C.E., the beginning of the Second Temple period. (Customarily, the parchment upon which the verses are written also shows the word for "Almighty," which is made up of the first letters of "Guardian of the door of Israel.") The solemn feast of Passover, too, commemorates a sacrificial marking of the "doorposts and lintel" of an observant household (Exodus. 12:7). In the New Testament, Christ said, "I am the door" (John 10:9).

We have assigned names to the various parts of doors: jambs, hinges, lintels, and thresholds, or sills. Grooms still carry brides over thresholds, and perhaps vice versa, which would not change the enduring significance of a doorsill as demarcating a shift from public arena to intimate space, an entirely different world.

The Romans assigned different gods to different parts of doors. The virgin goddess Cardea—a Vestal goddess—governed thresholds and door pivots, protecting the home, and especially the children inside, from evil spirits. Sometimes Cardea was not a virgin goddess, but a spring nymph, married to the two-headed god Janus, who ruled over "beginning, opening, doorways, entrances and endings." Janus gave his name to the first month of the year, and in pre-Roman Italy was a sun god, opening and closing the day.

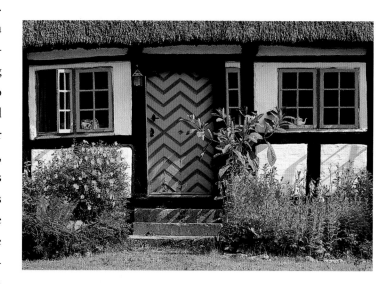

The color of a door may also protect the home, or endow it with certain qualities. In China, red is the luckiest color of them all, standing for joy and happiness, the sun, fire, and the magical phoenix, that splendid bird that rises from its own ashes. In countries of Christian culture, blue is the color of the Virgin Mary, and of loyalty, fidelity, constancy, faith, and Heaven itself—Mary's blue mantle over all.

In all times and places, we have sought much protection for our homes because that is where we are most vulnerable, where we keep what we value most: our loved ones, our prized possessions, and our truest selves. When we welcome others into our homes, we offer them what we treasure: comfort, friendship, enjoyment, and our private selves. Just as ritual, architectural and artistic, universally marks doors and, in the absence of doors, doorways, so is welcoming a visitor (and being a visitor received) universally ceremonial. How we usher a guest into our home says much about the degree of intimacy we feel. Hospitality is still sacred: tales of treachery toward an invited guest—even more than of guest to host—still send off shock waves. Fifteen hundred years ago, after the Herulian King Odoacer surrendered to him, Theodoric, King of the Ostrogoths of Northern Italy, invited Odoacer to dinner and had him killed. The European world (which had previously considered Odoacer the barbarian of the two) was stunned.

And of course the cover of a book is a door. We invite you to turn these pages and enjoy the doors we have selected for your imaginative and visual pleasure. They are neat, ramshackle, quirky, exotic, elegant, intriguing, and uniquely evocative, a treasure trove of welcomes from the world over.

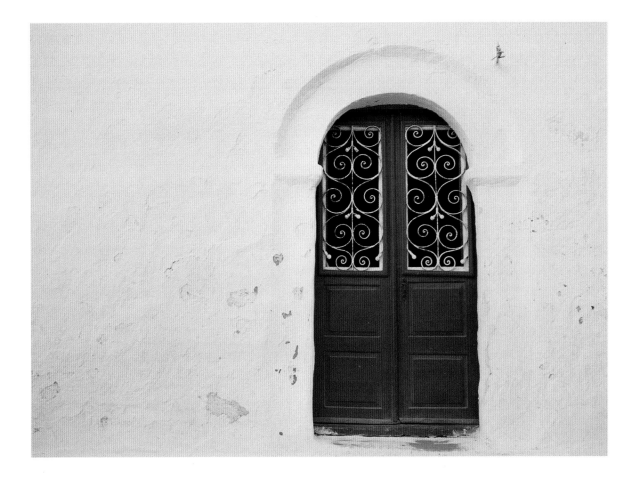

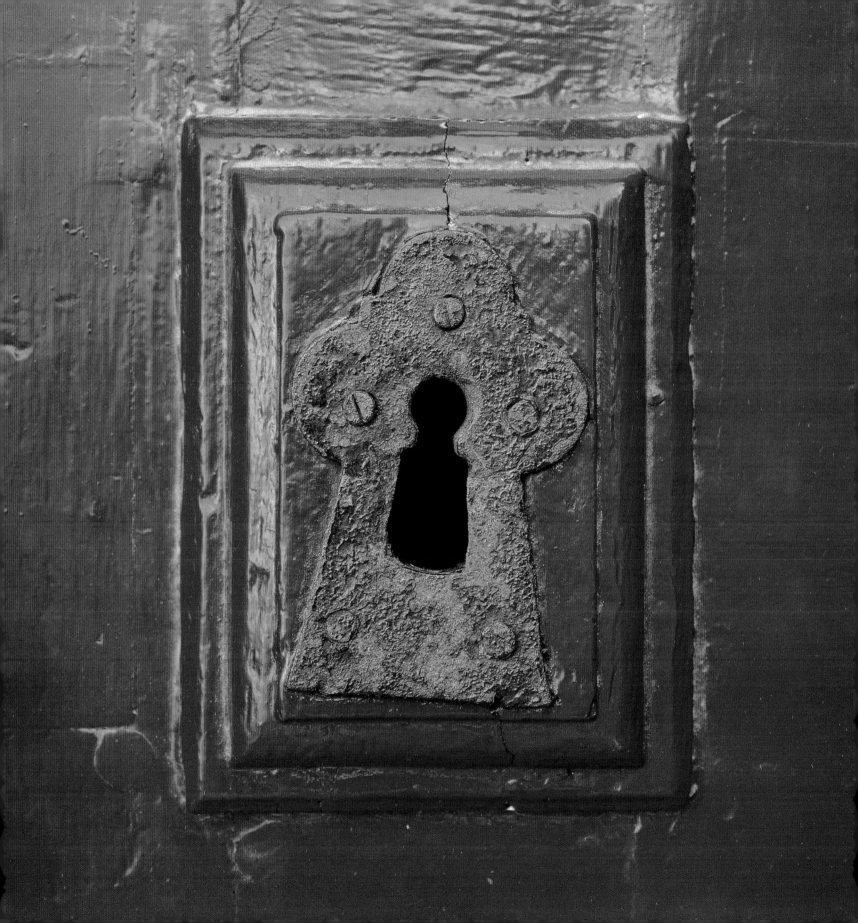

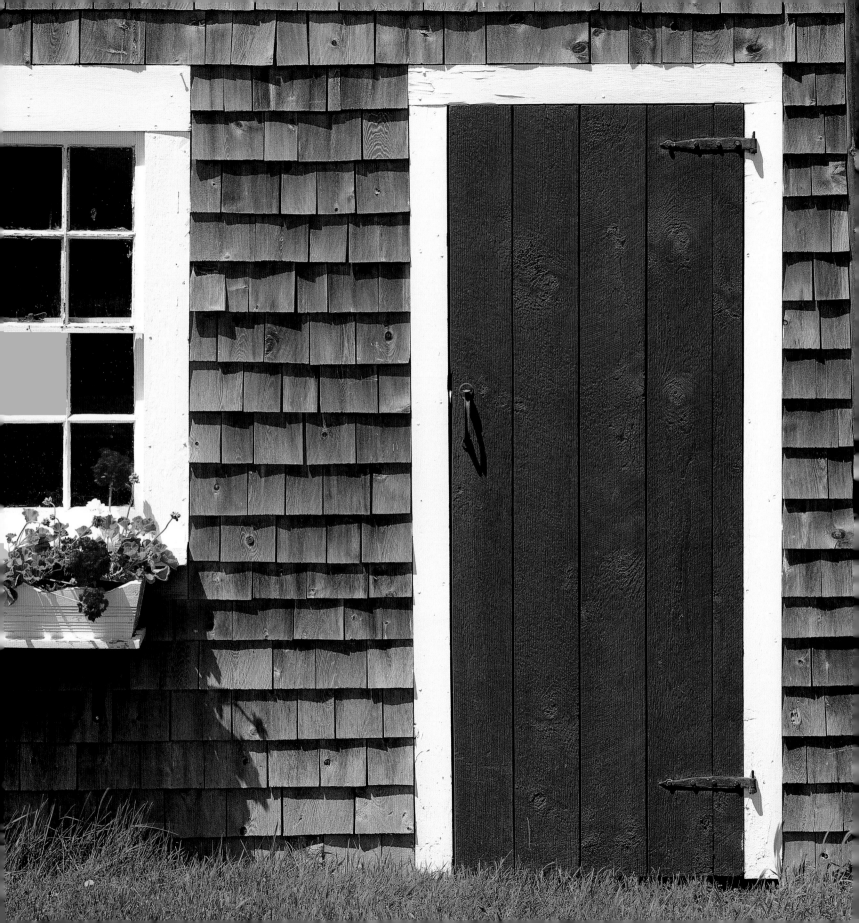

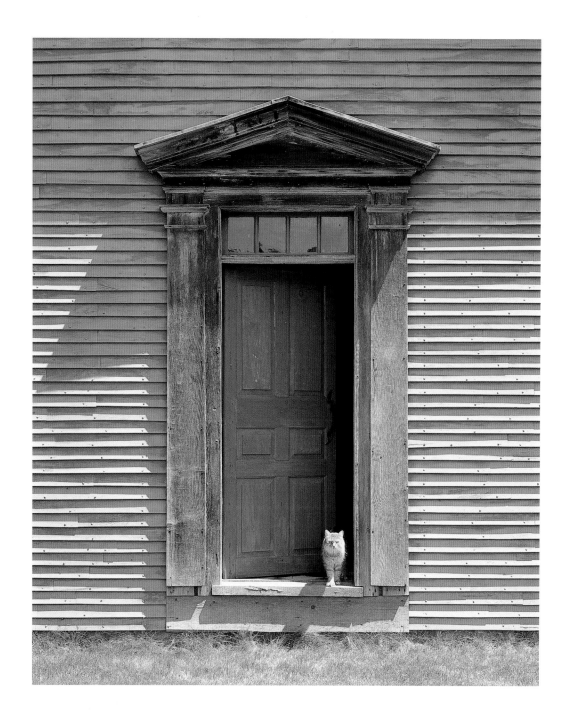

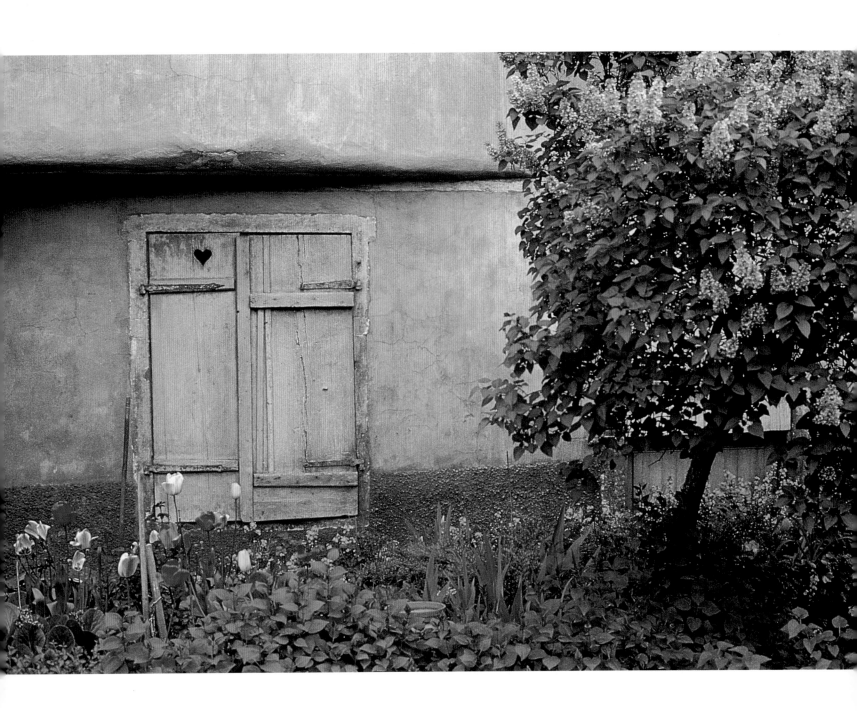

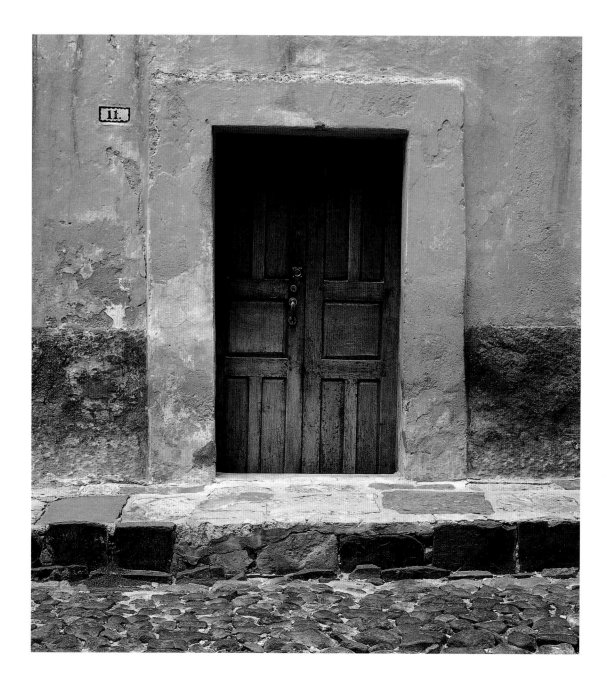

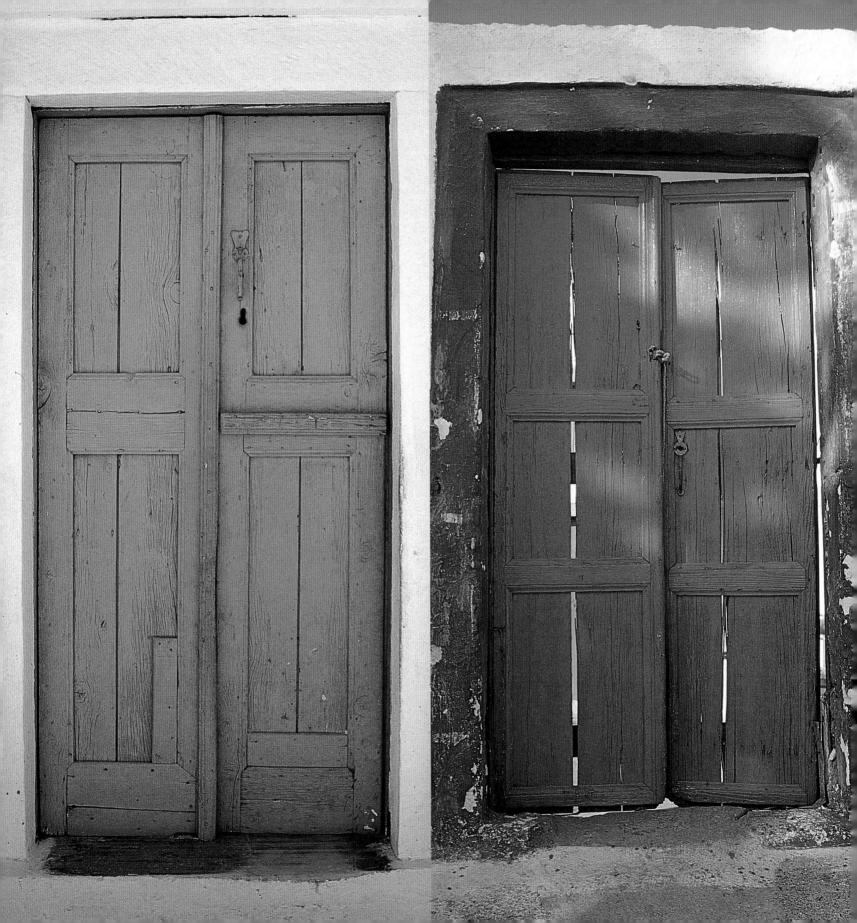

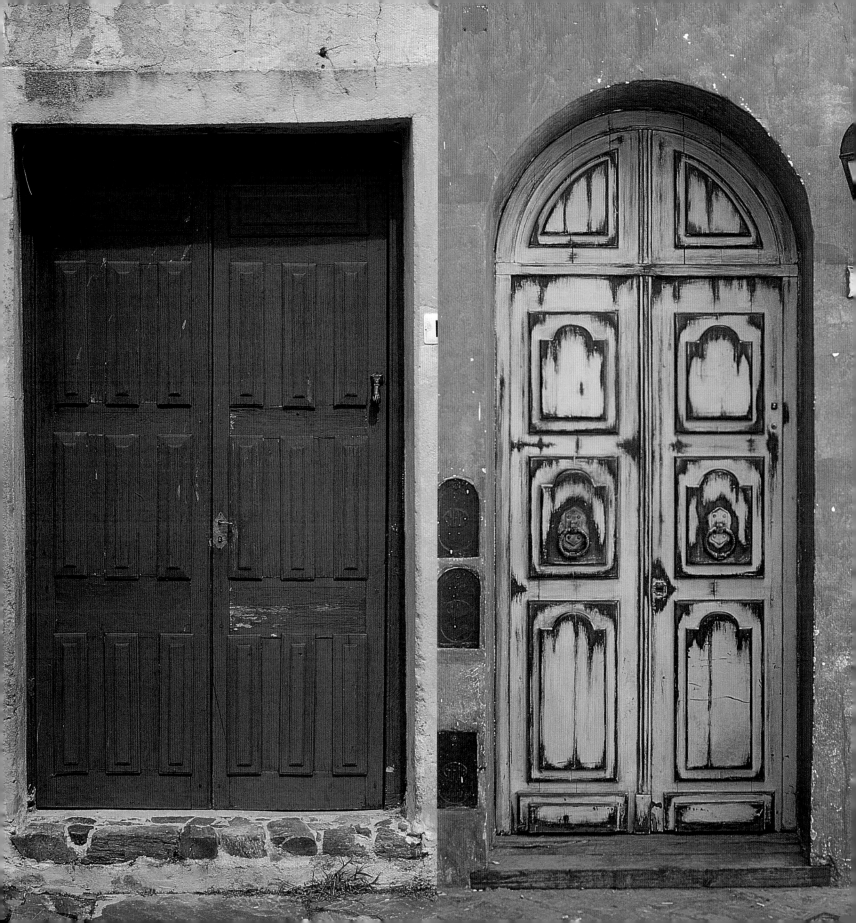

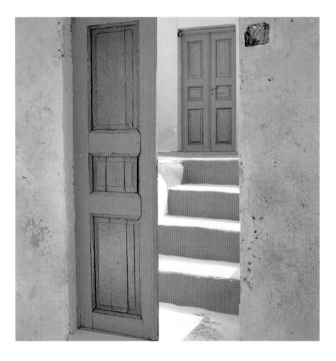

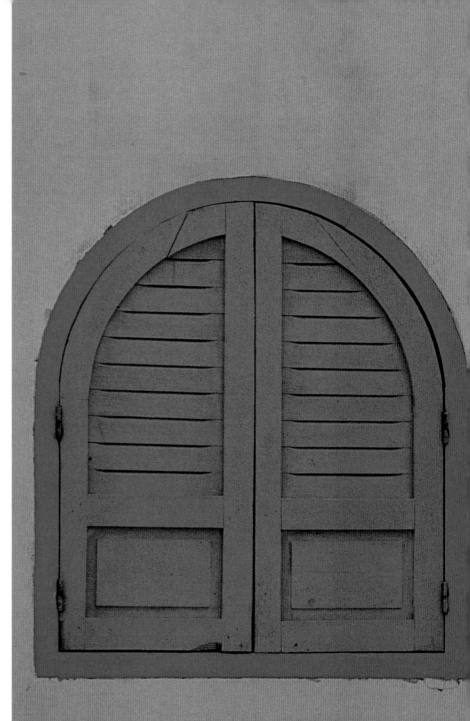

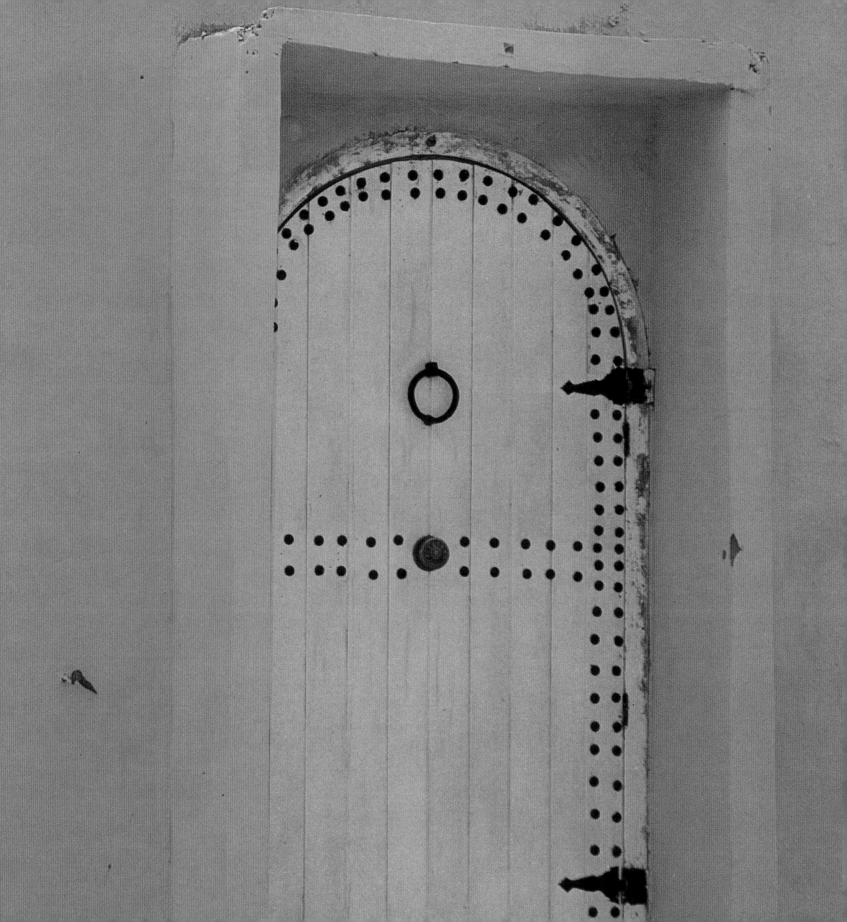

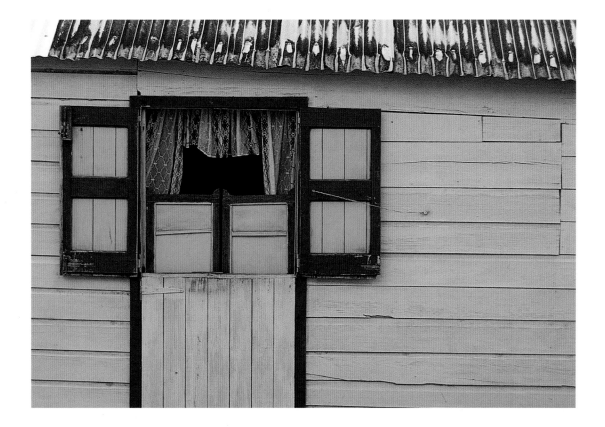

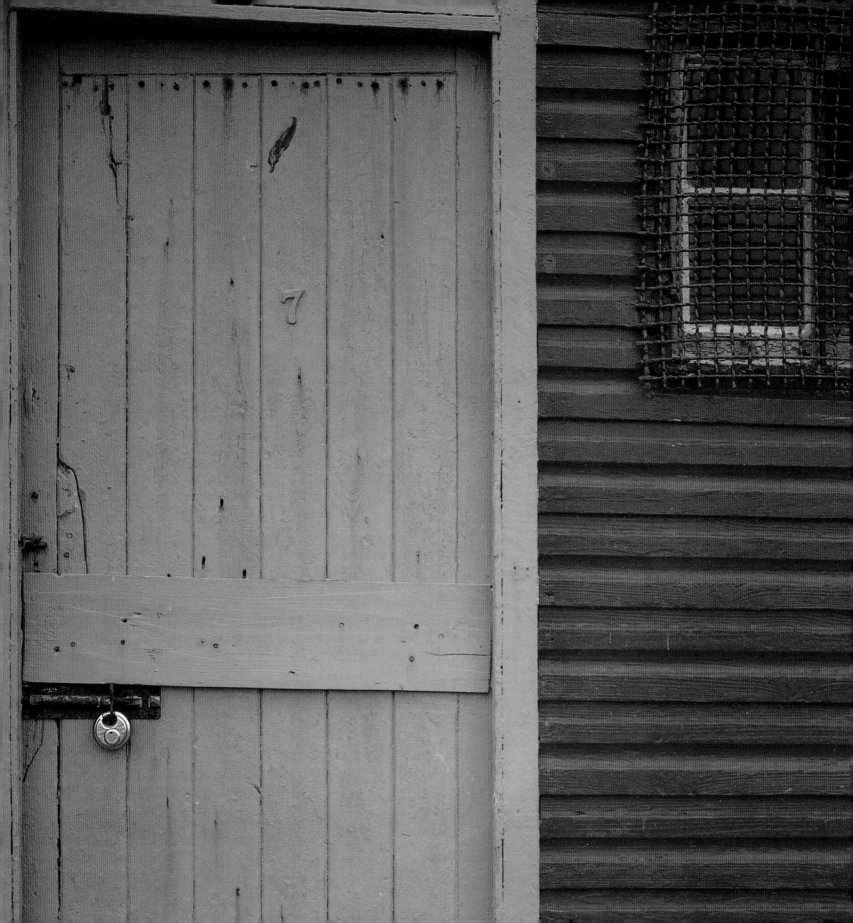

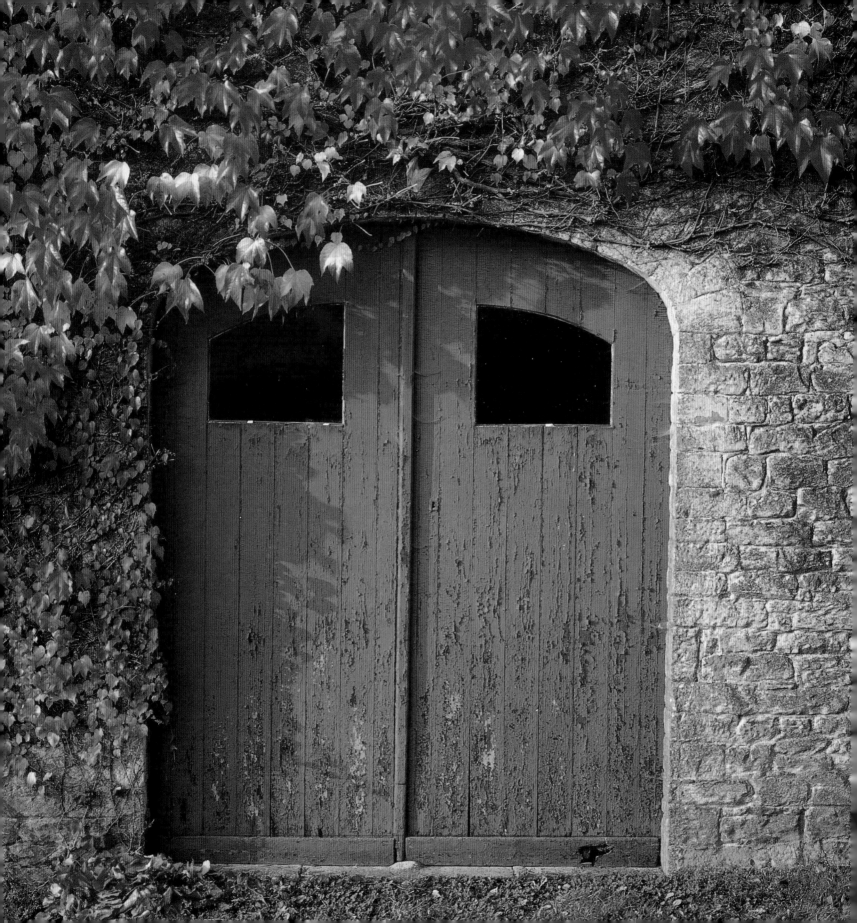

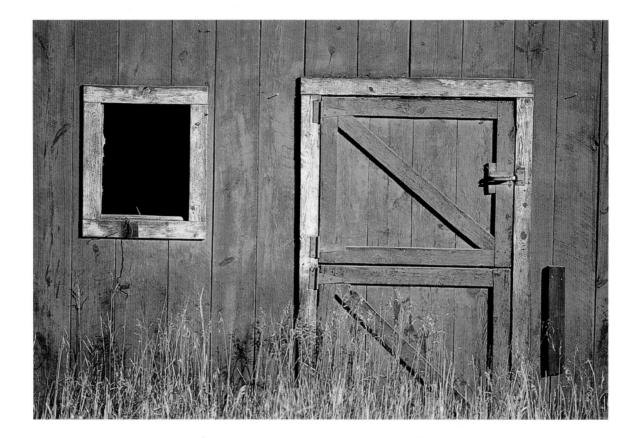

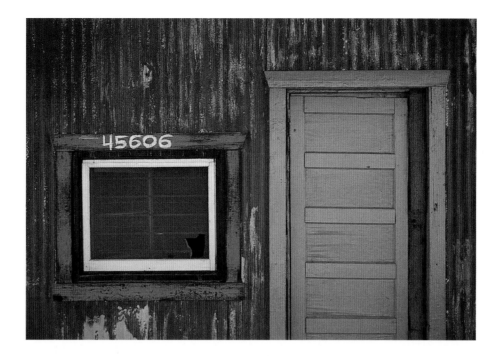

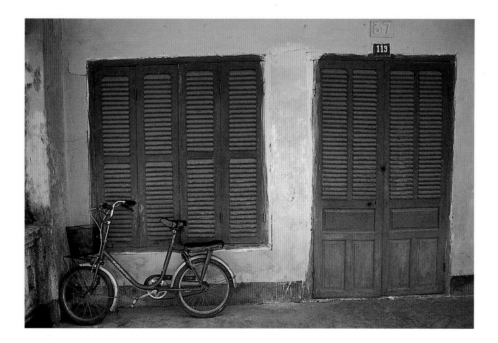

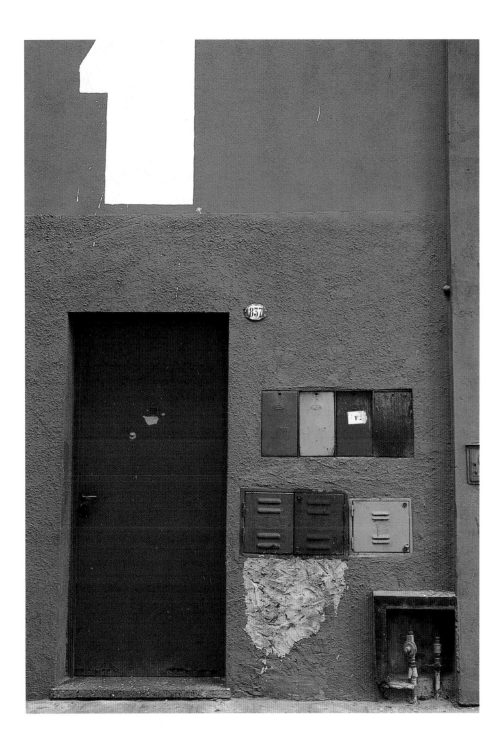

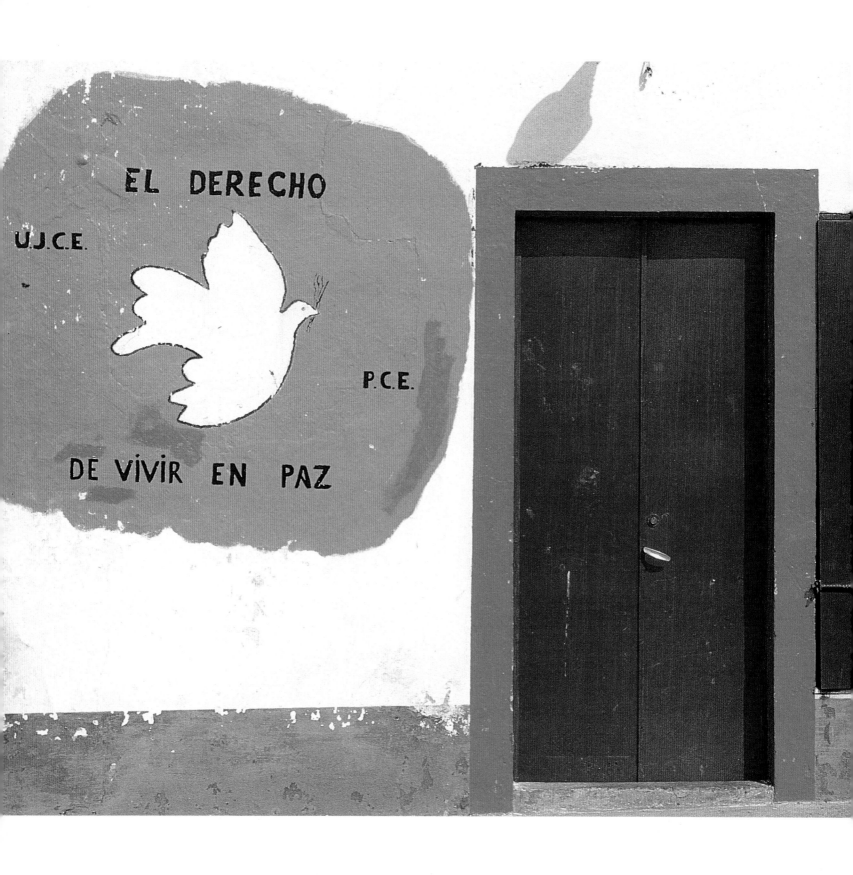

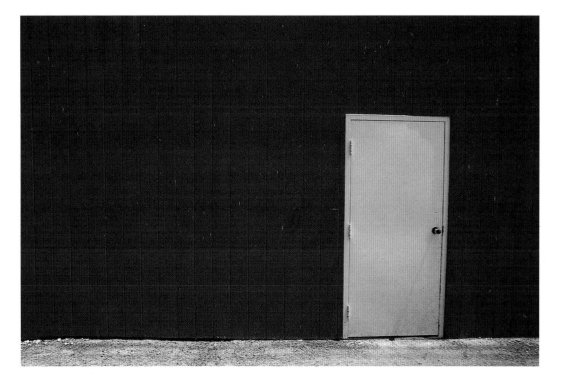

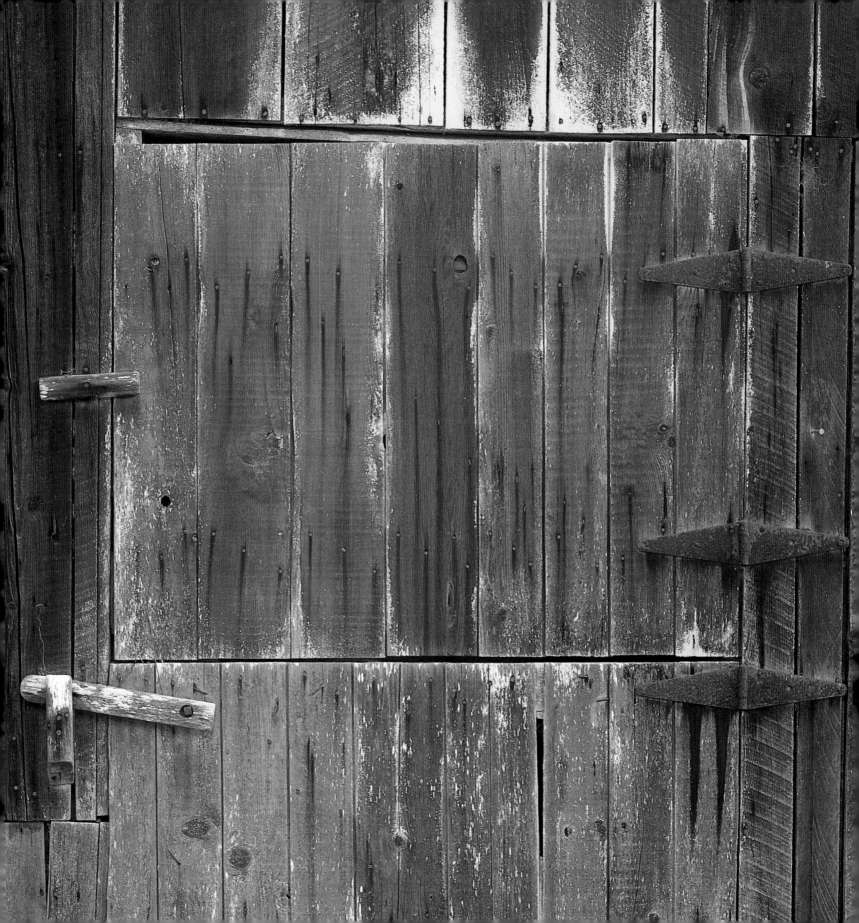

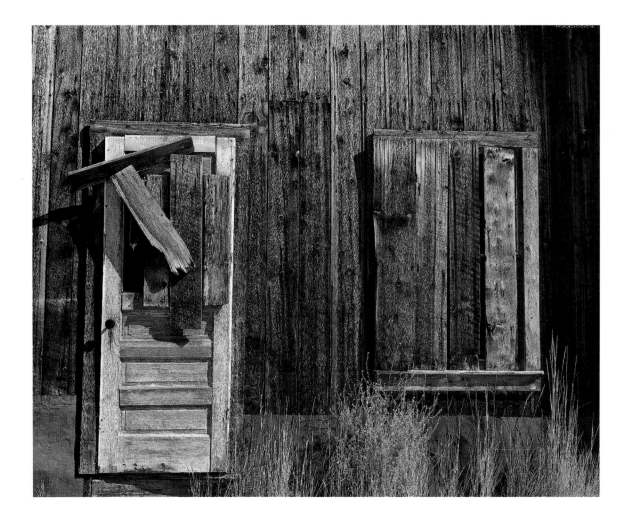

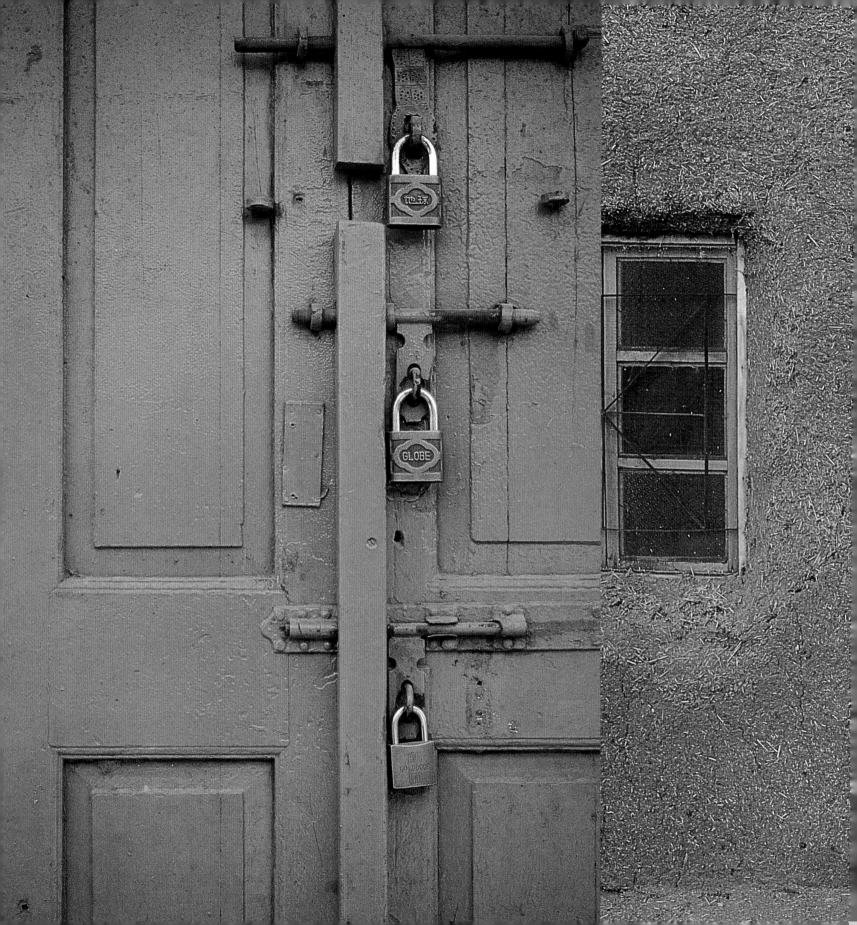

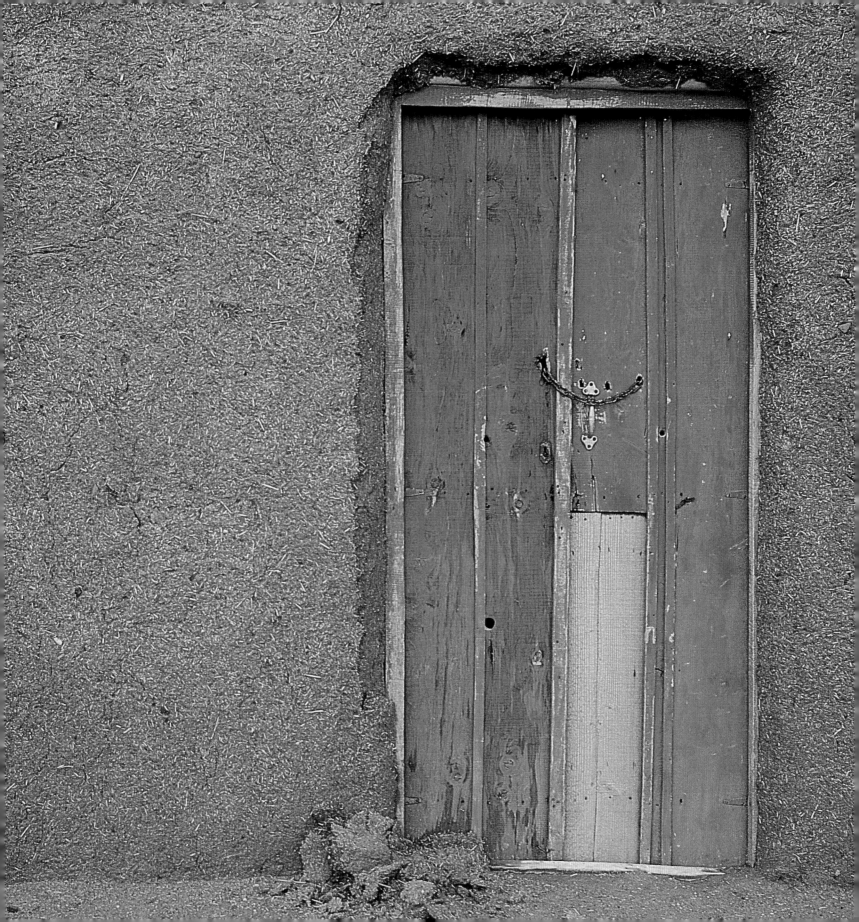

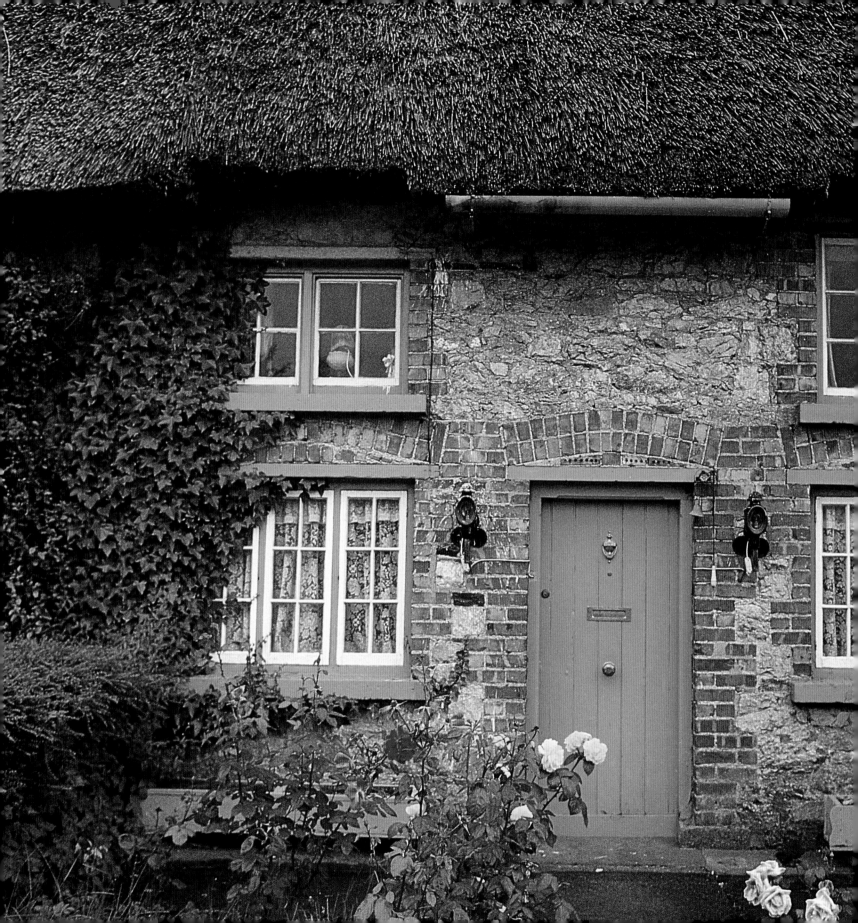

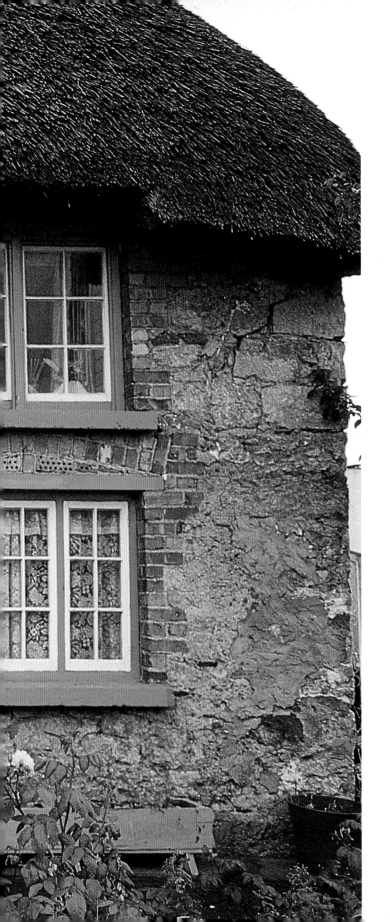
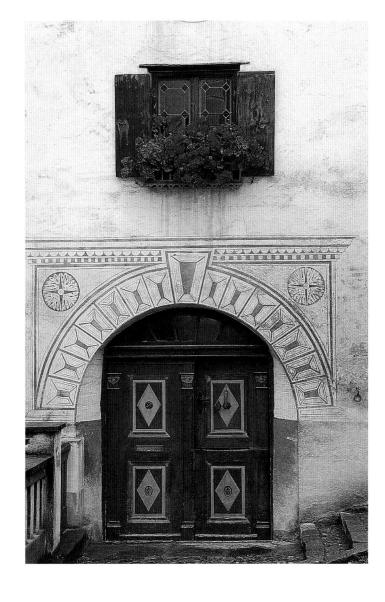

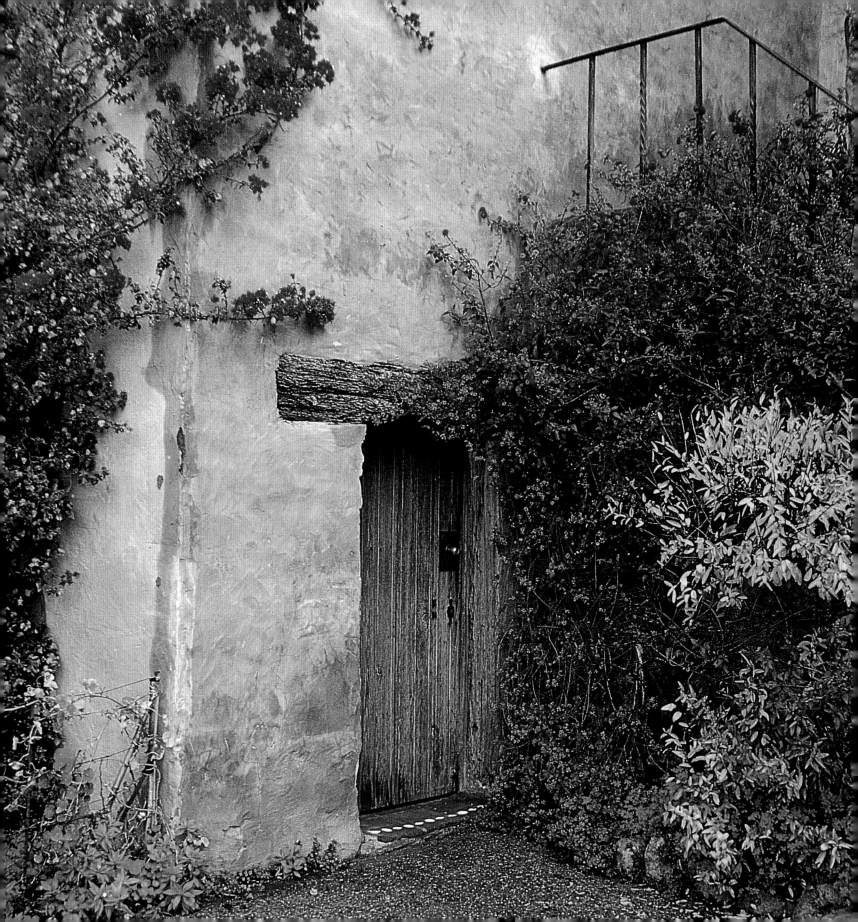

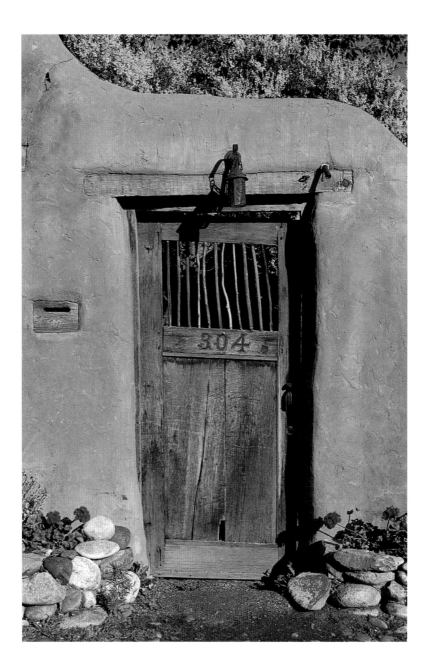

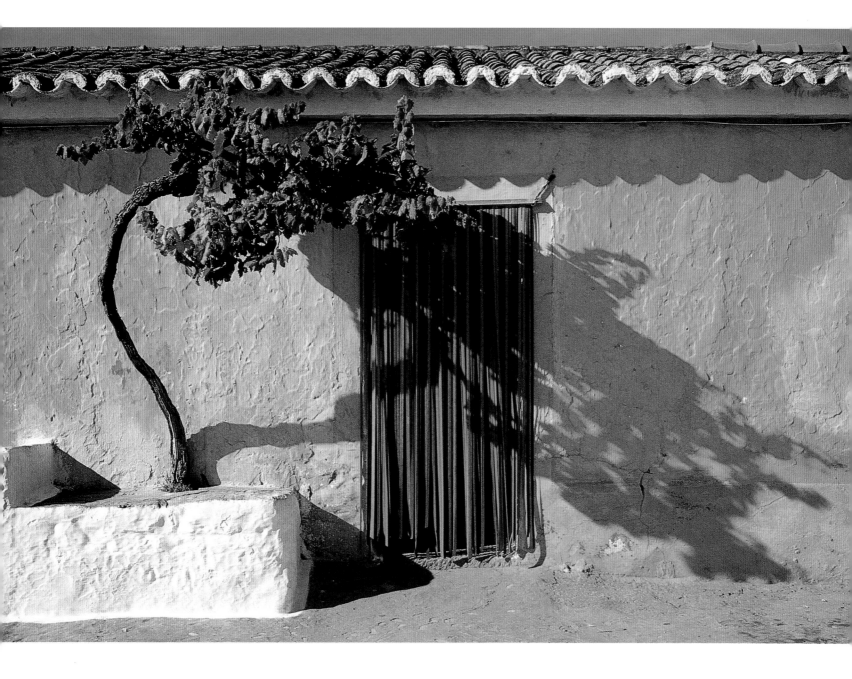

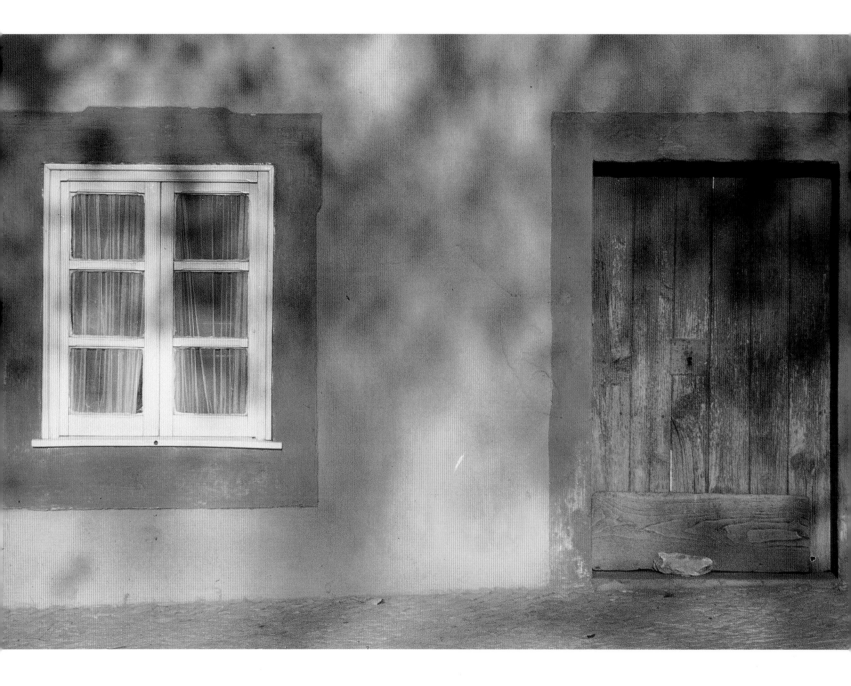

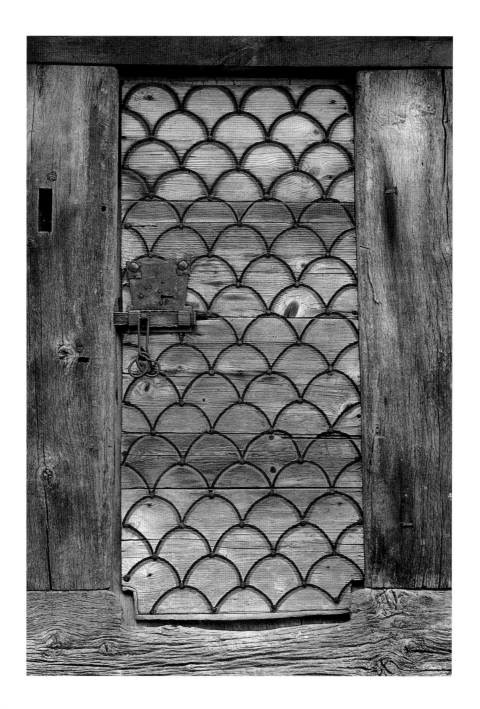

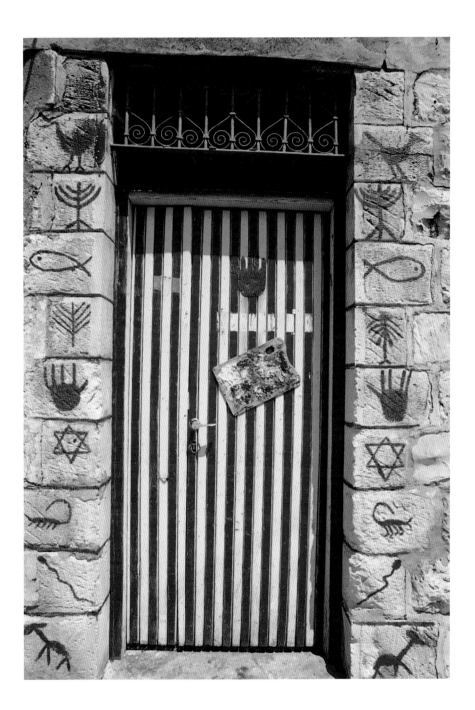

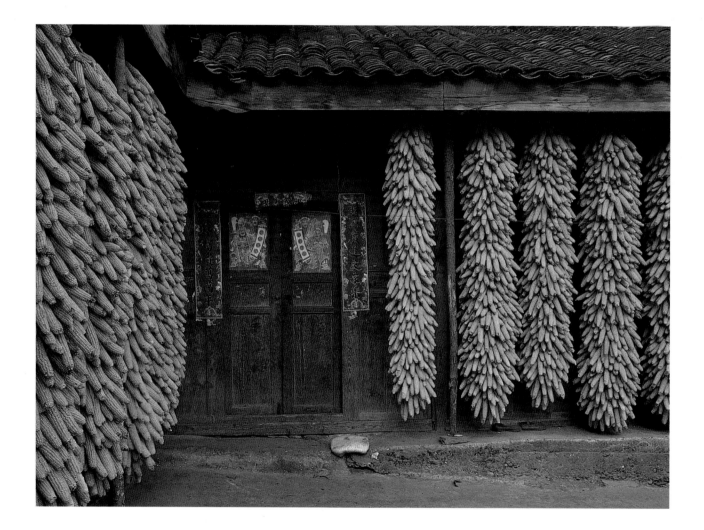

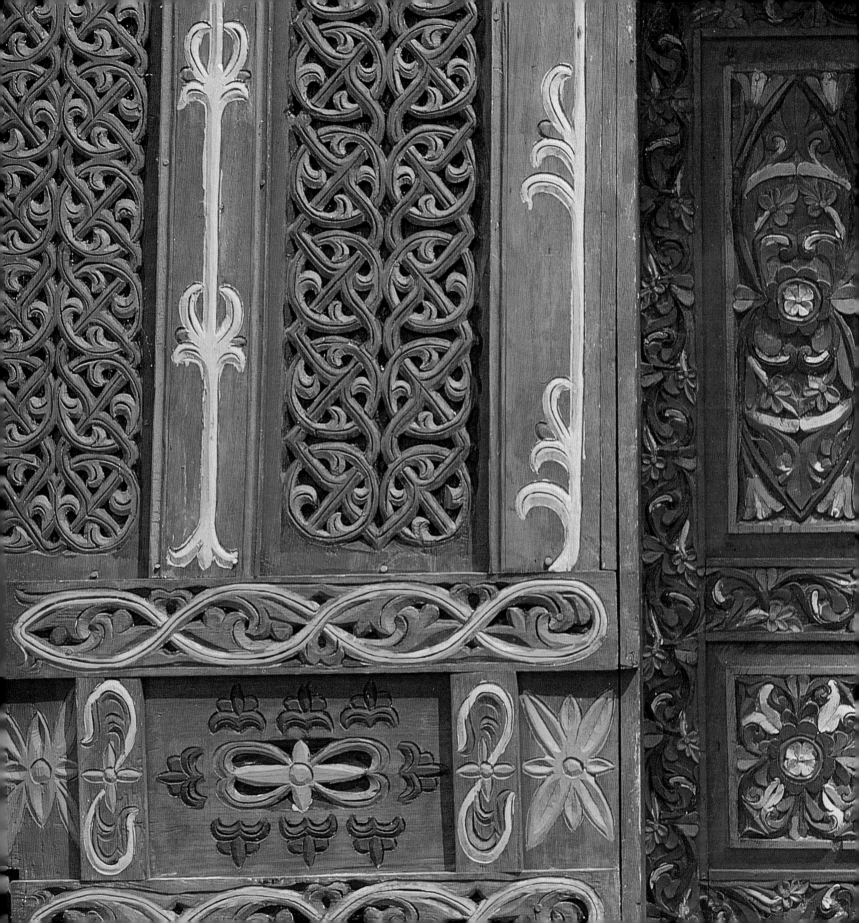

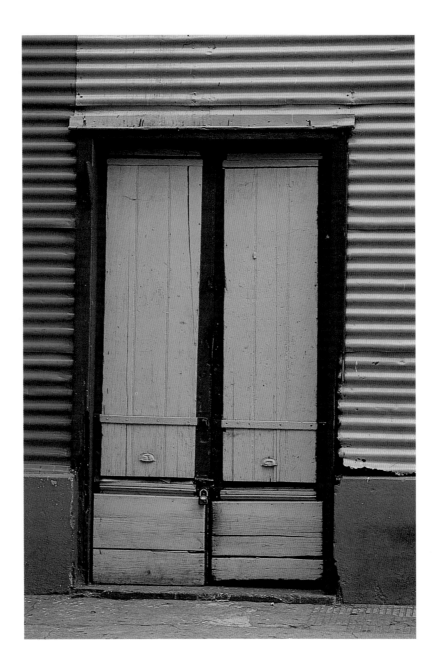

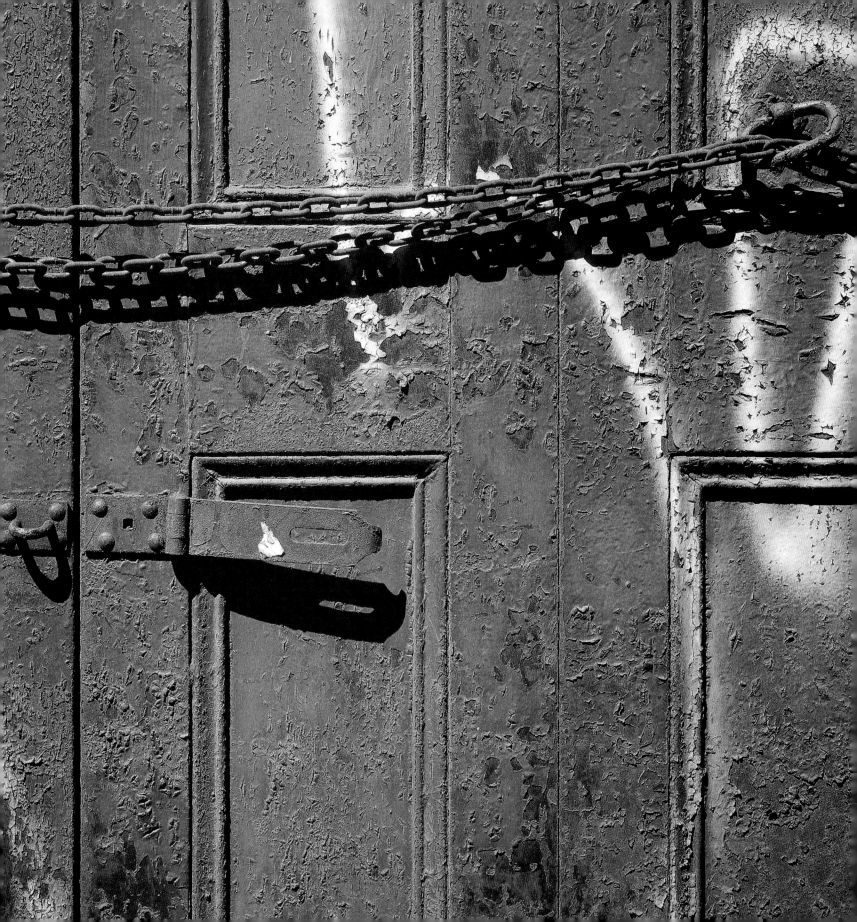

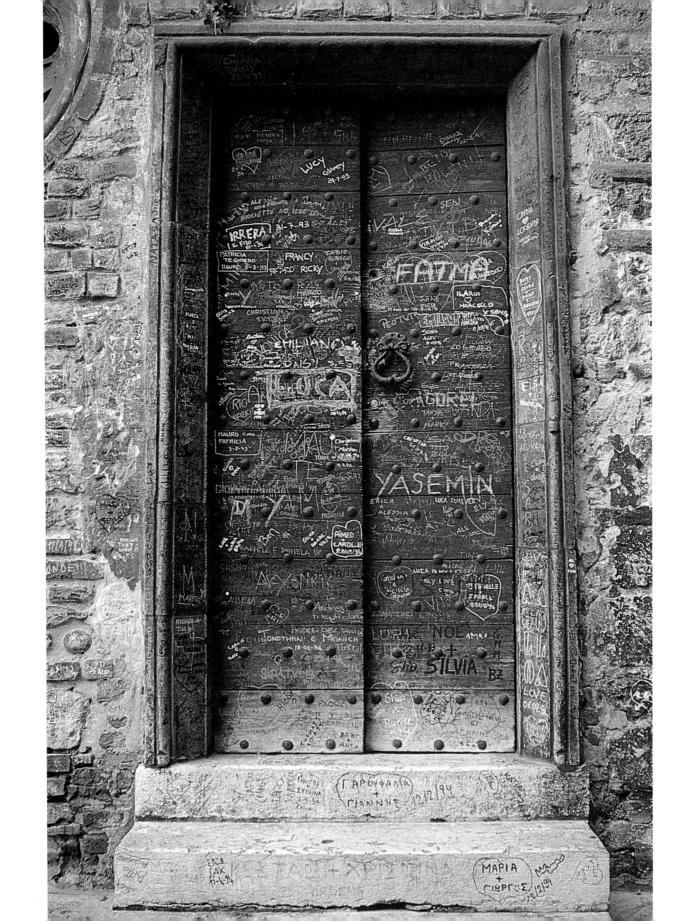

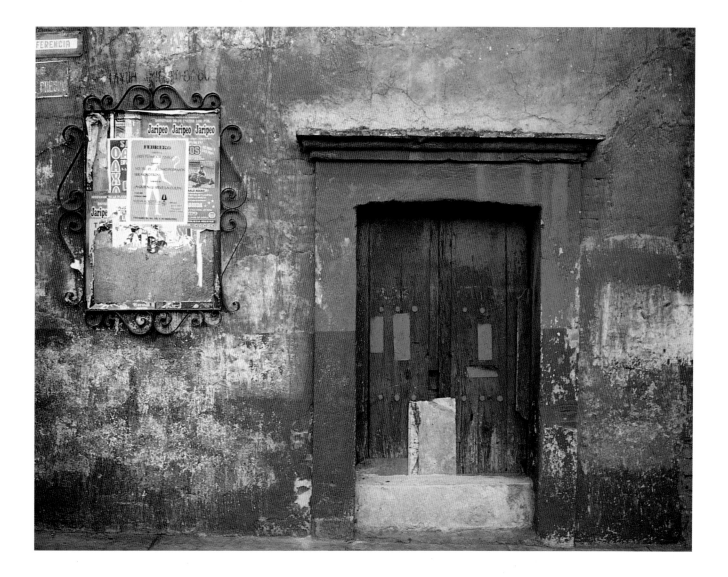

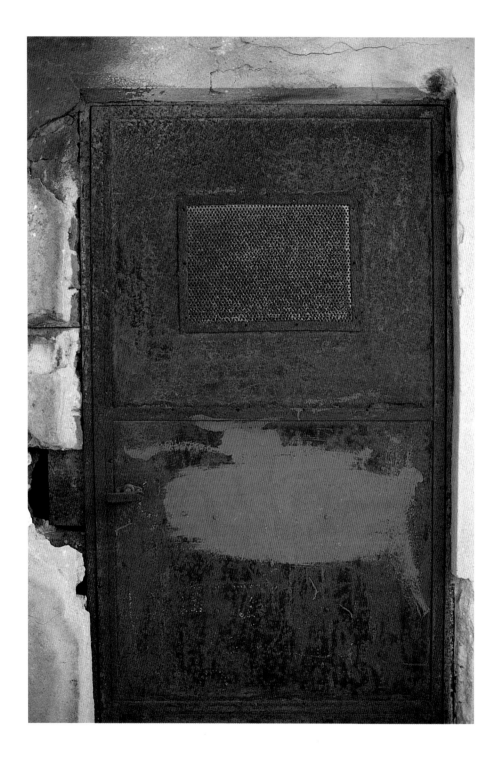

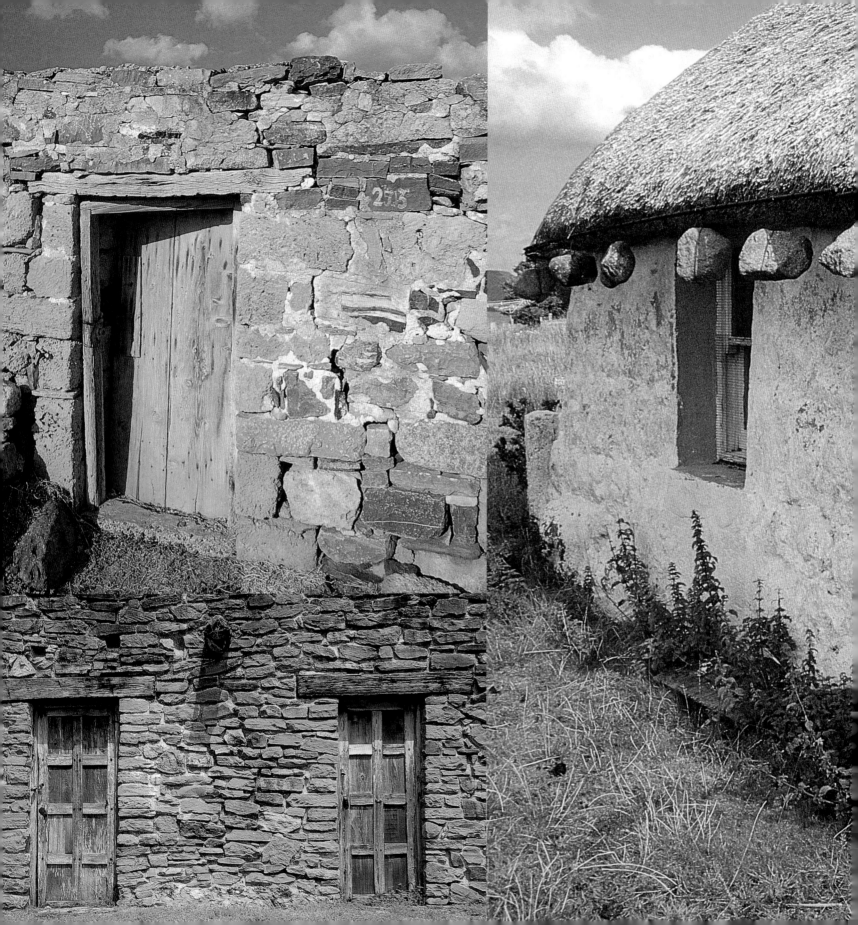

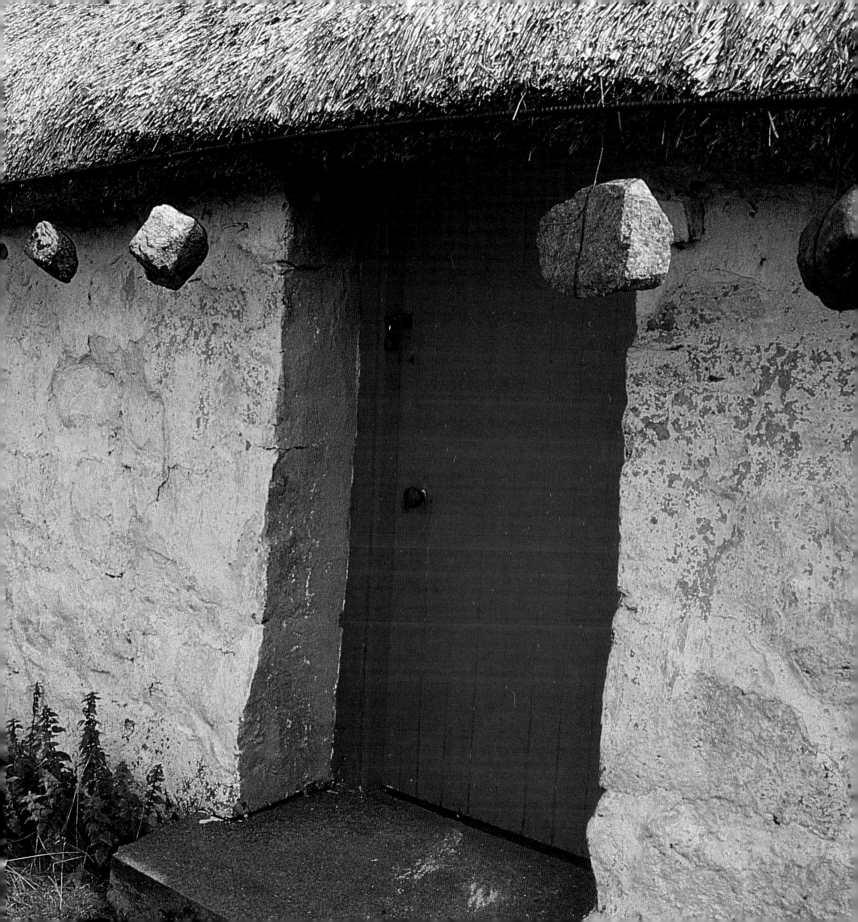

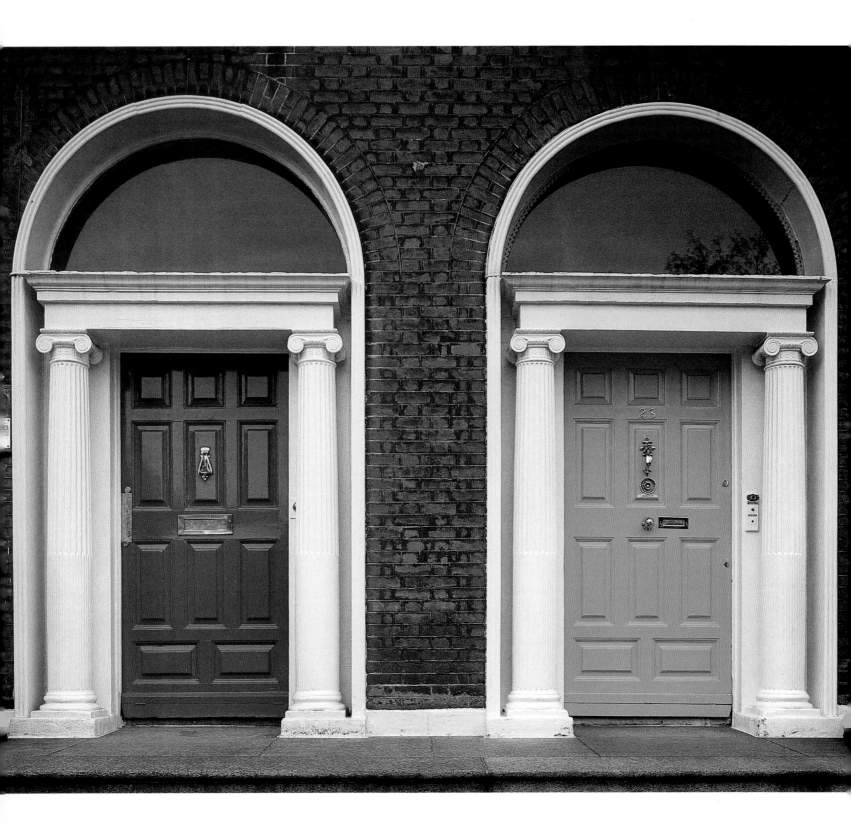

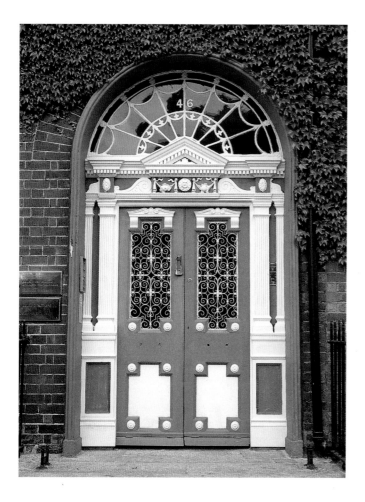
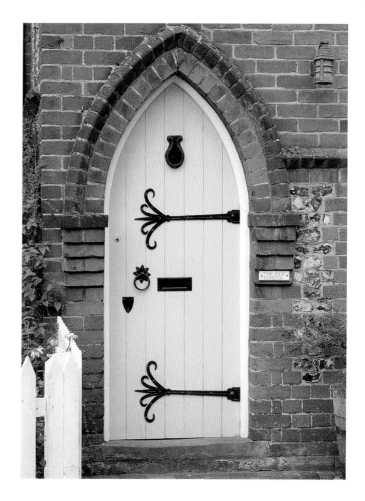

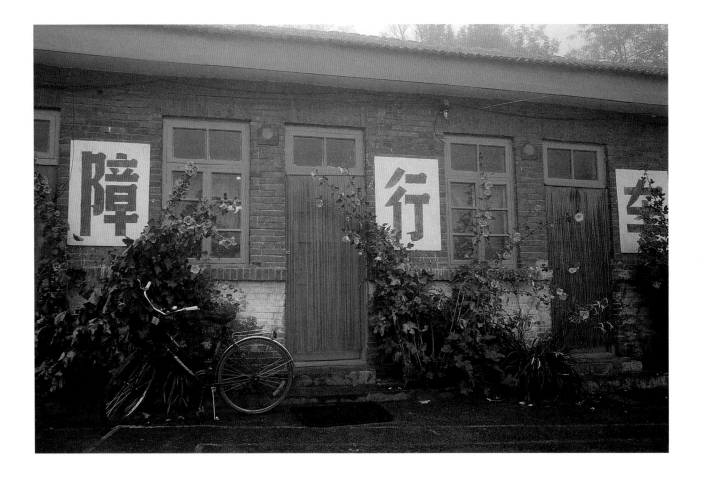

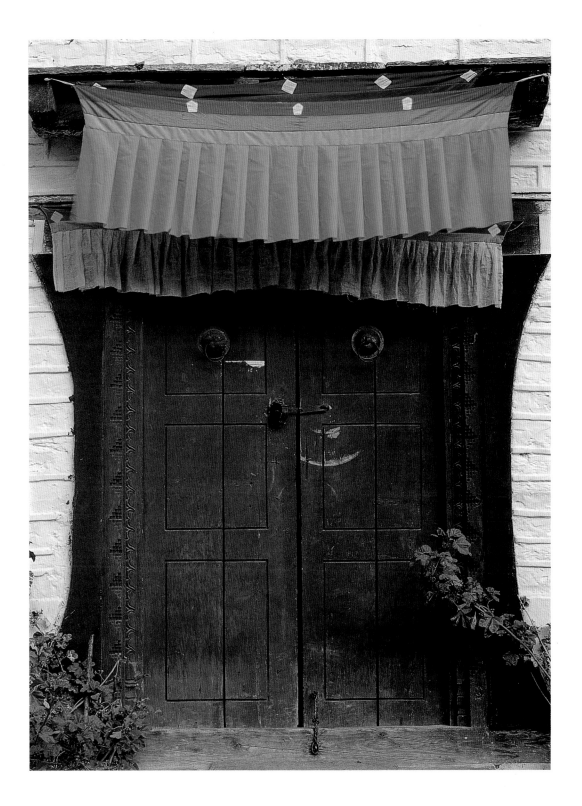

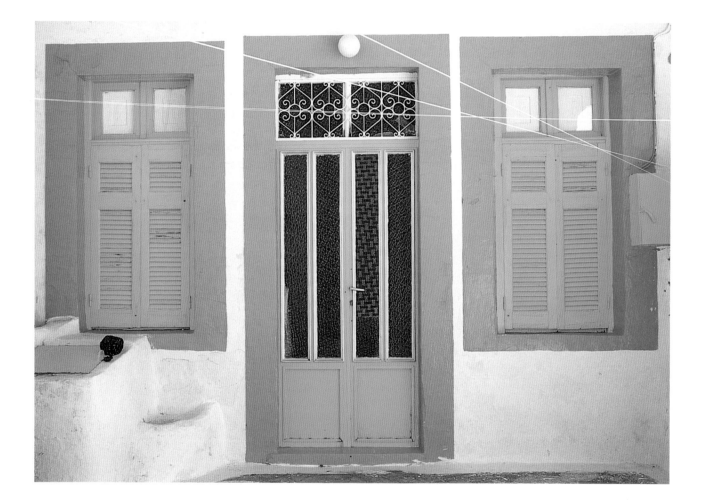

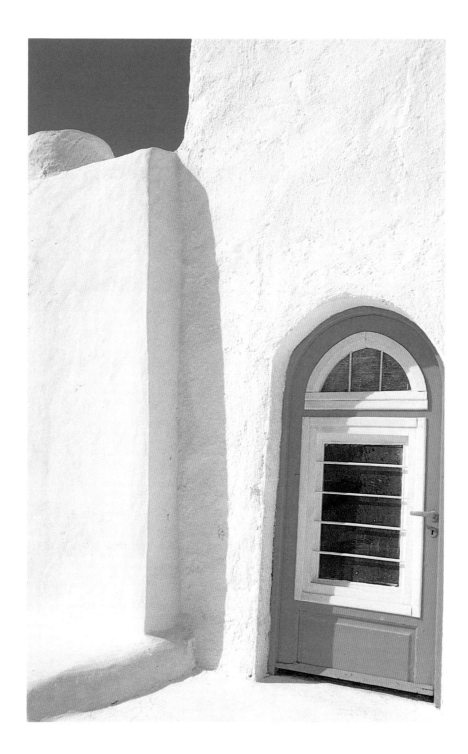

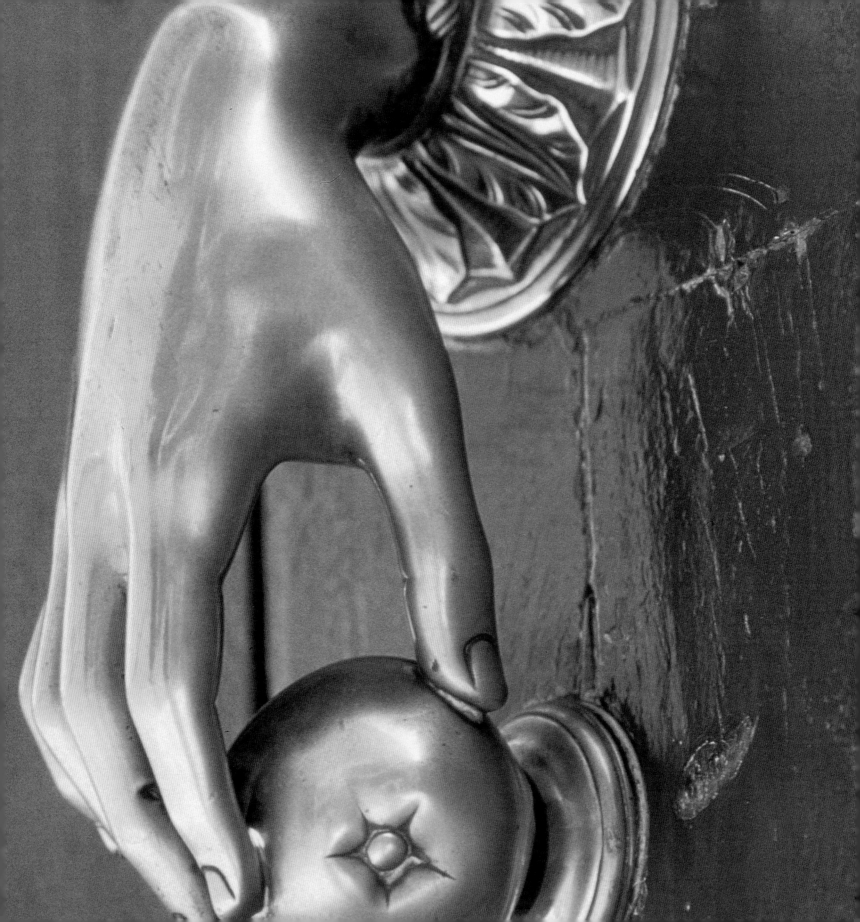

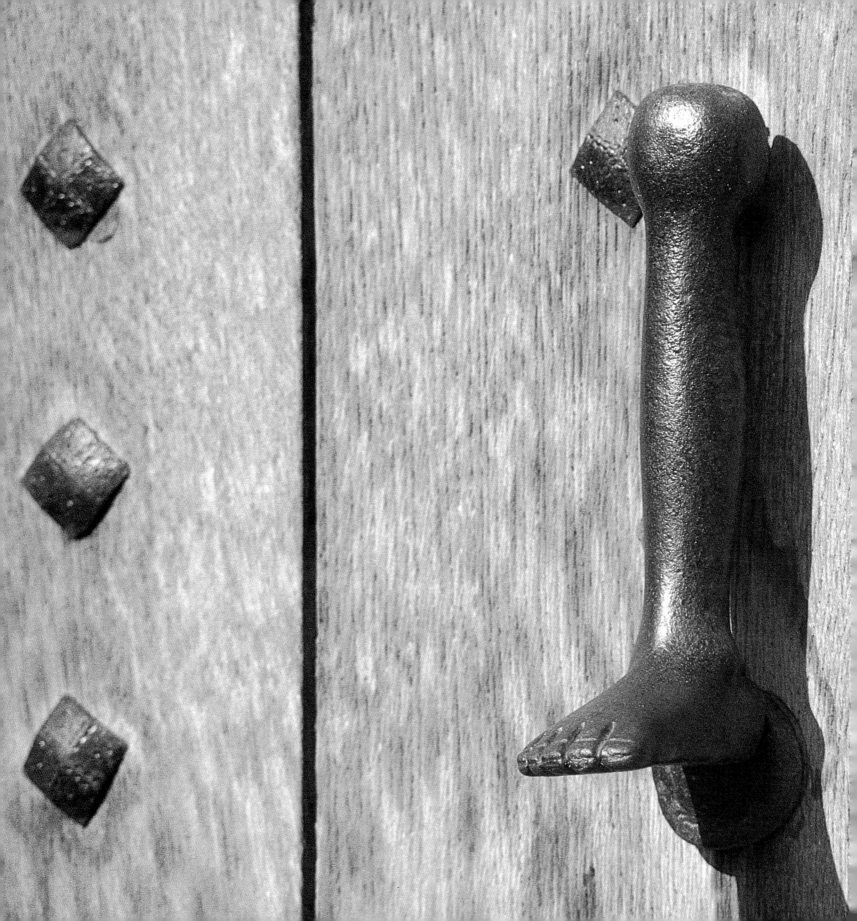

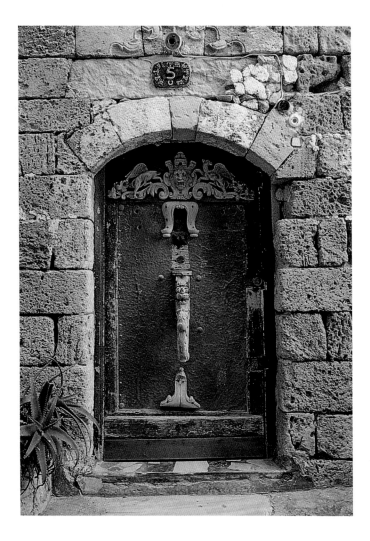
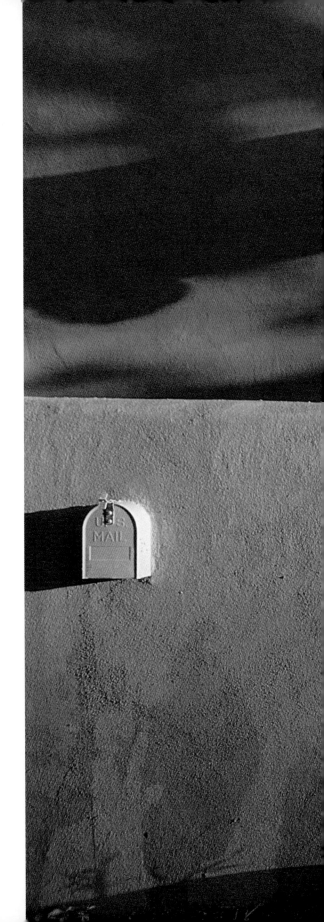

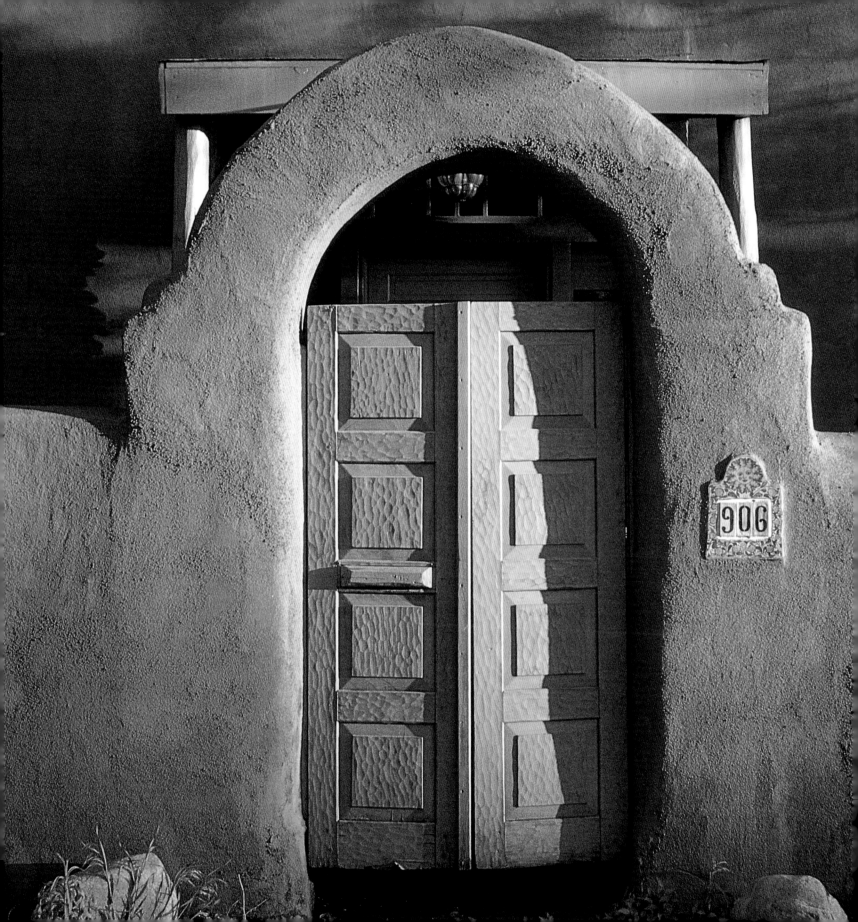

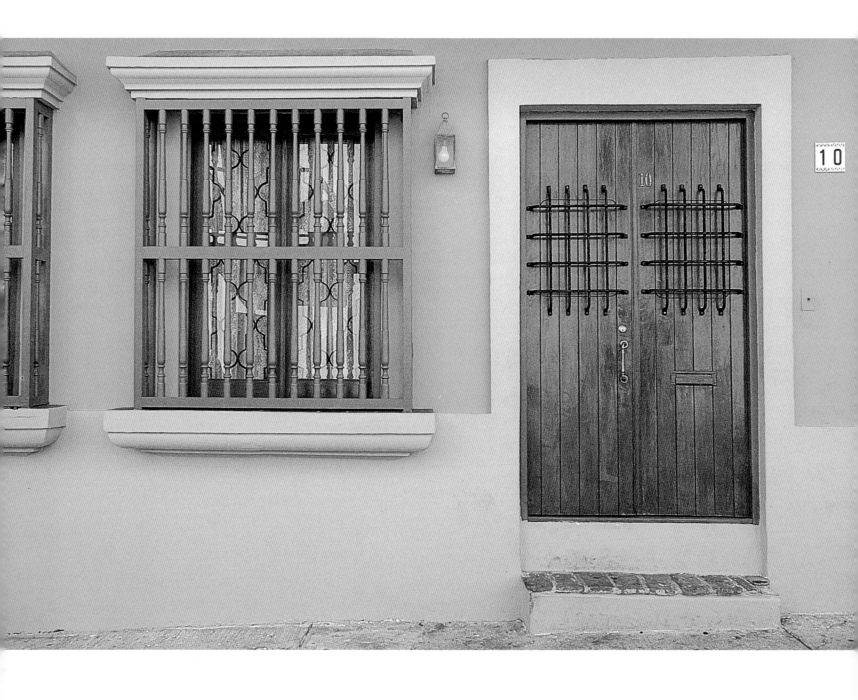

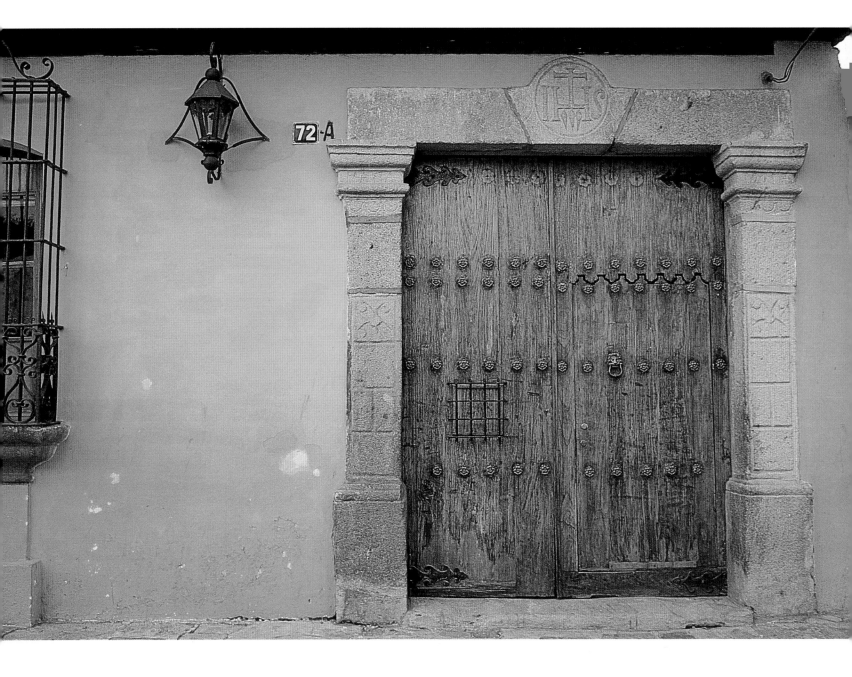

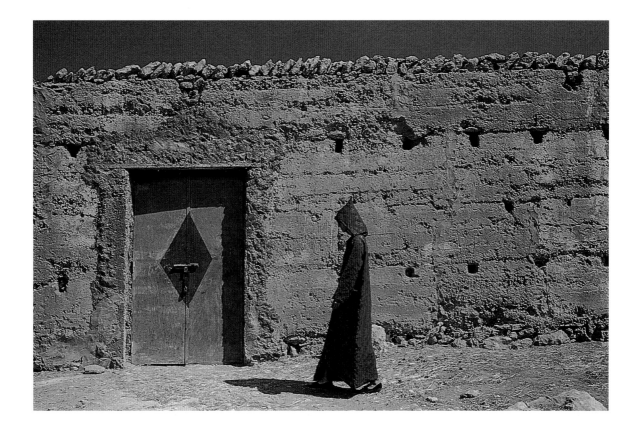

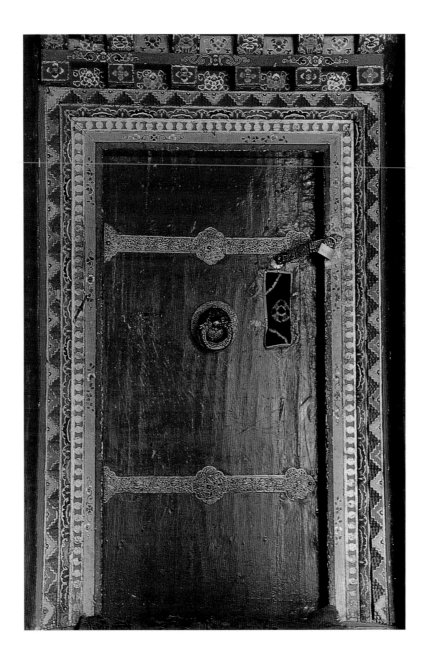

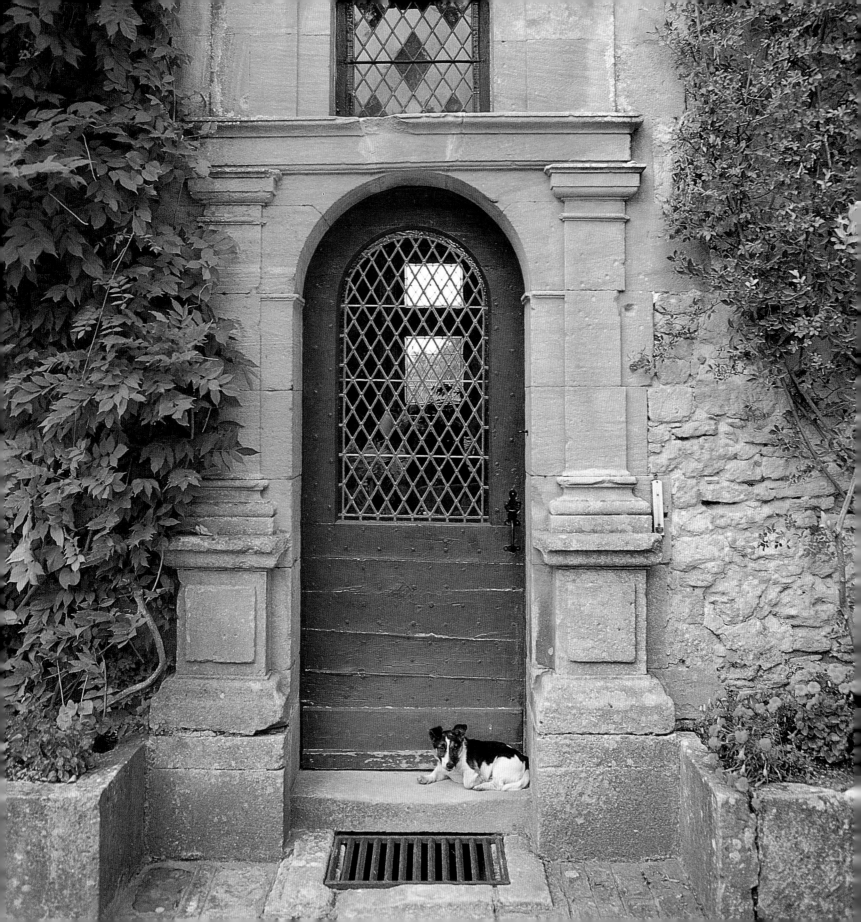

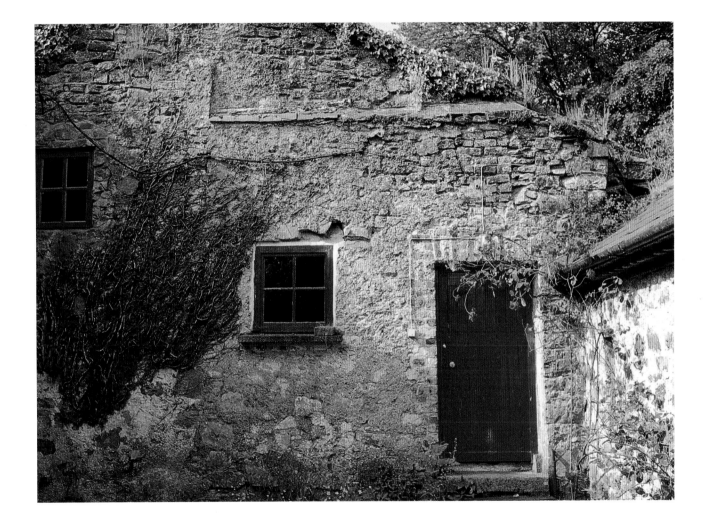

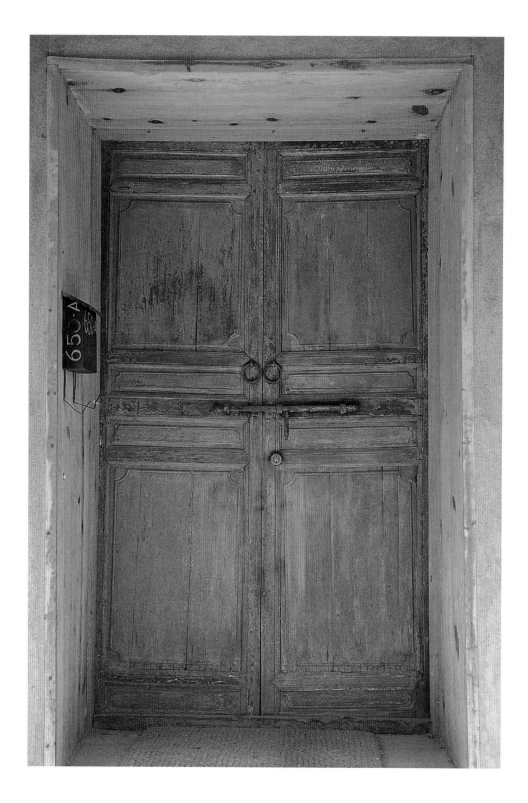

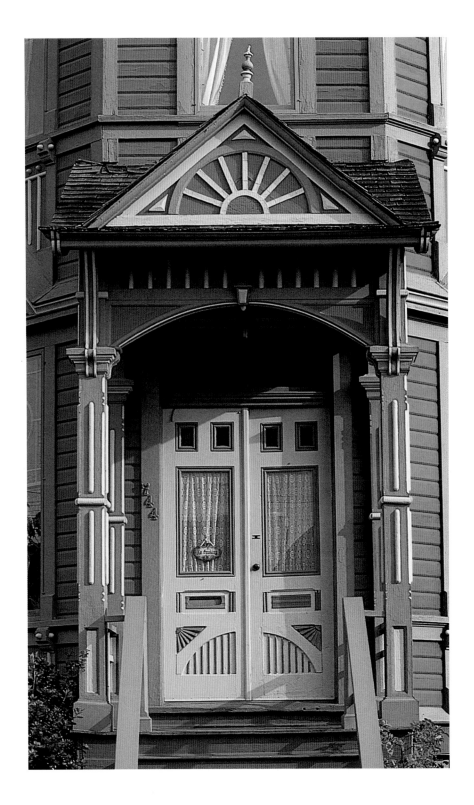

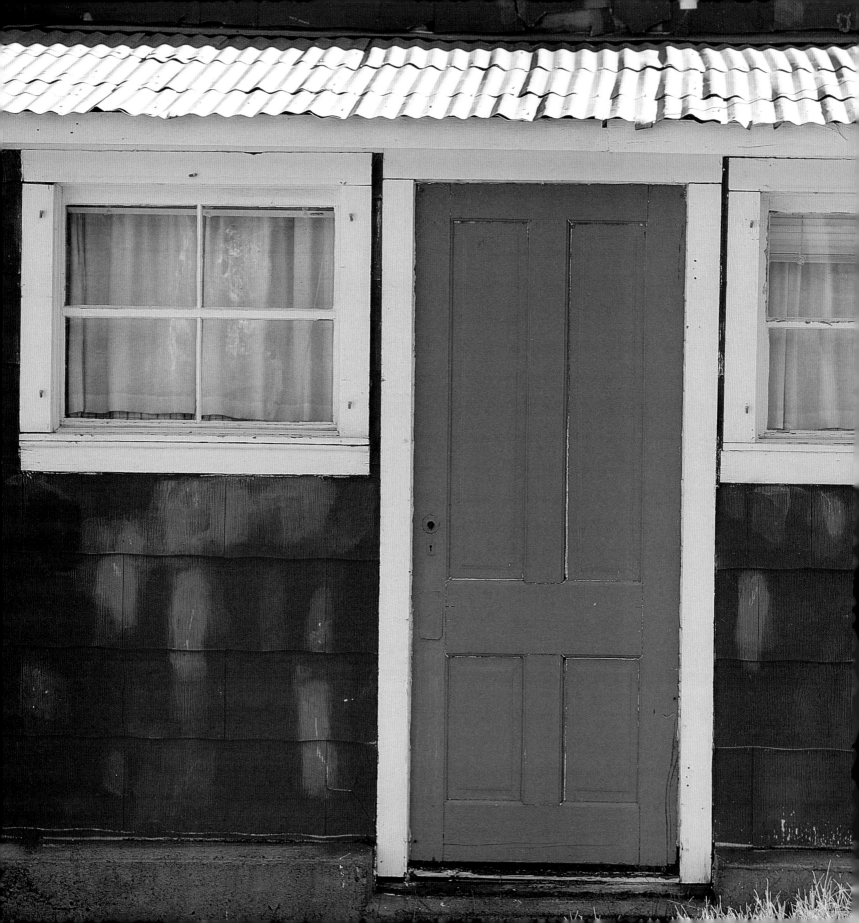

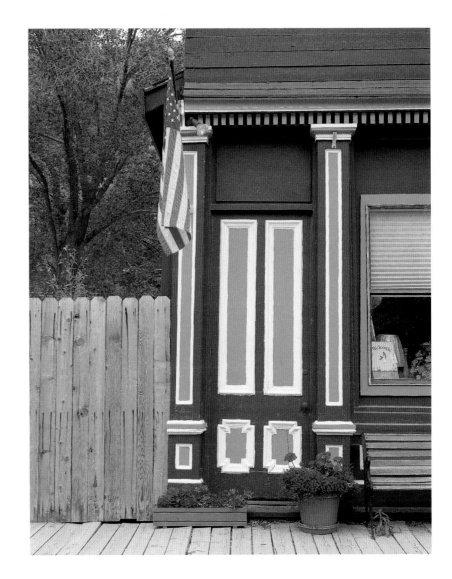

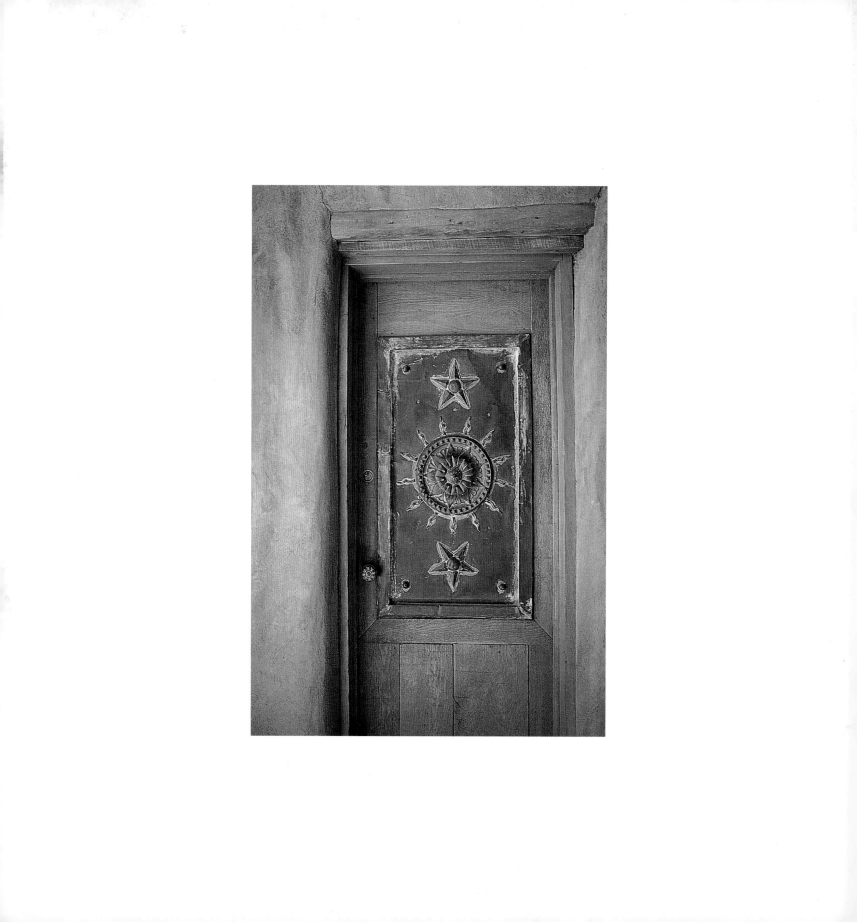

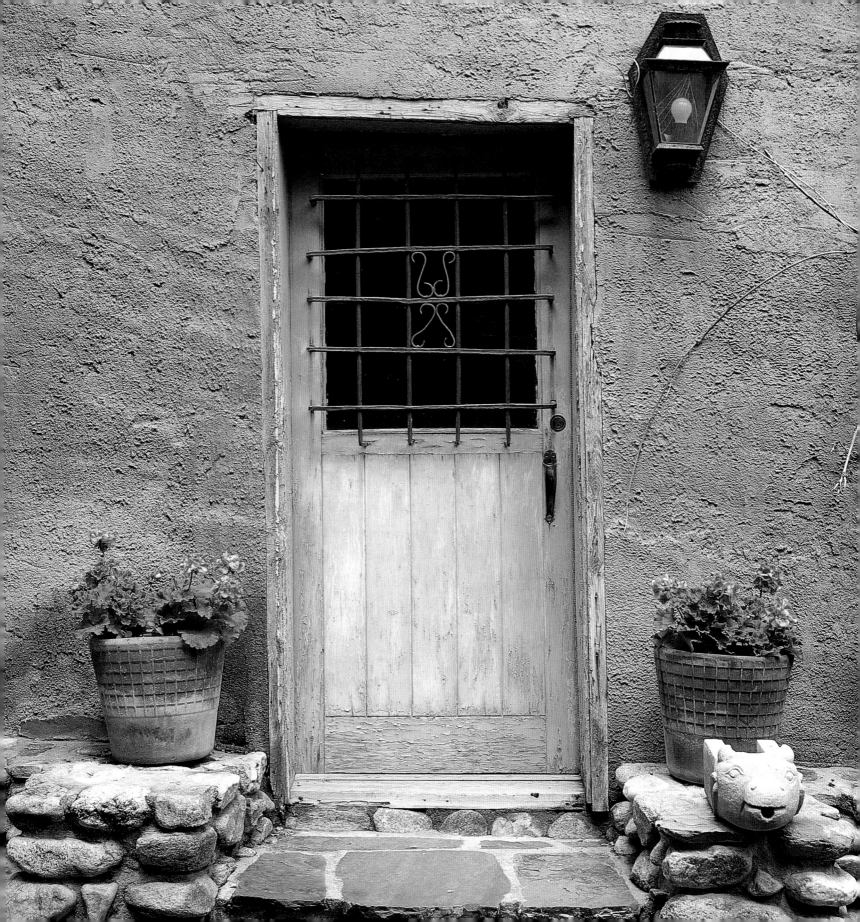

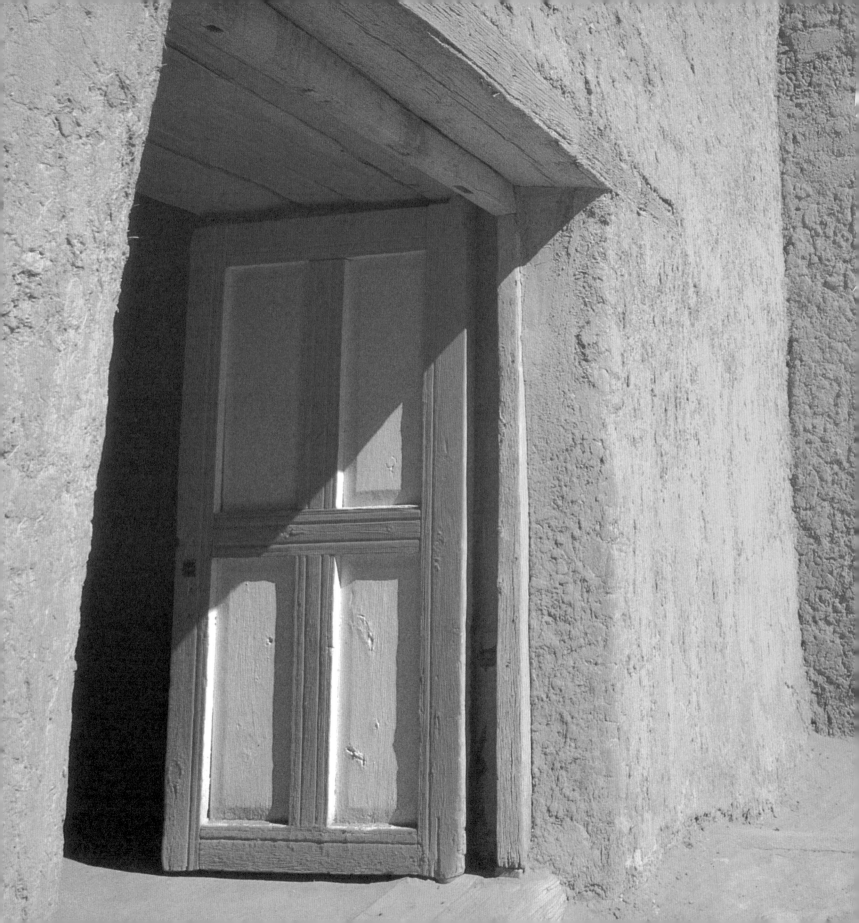